IMAGES
of America

YELLOW SPRINGS

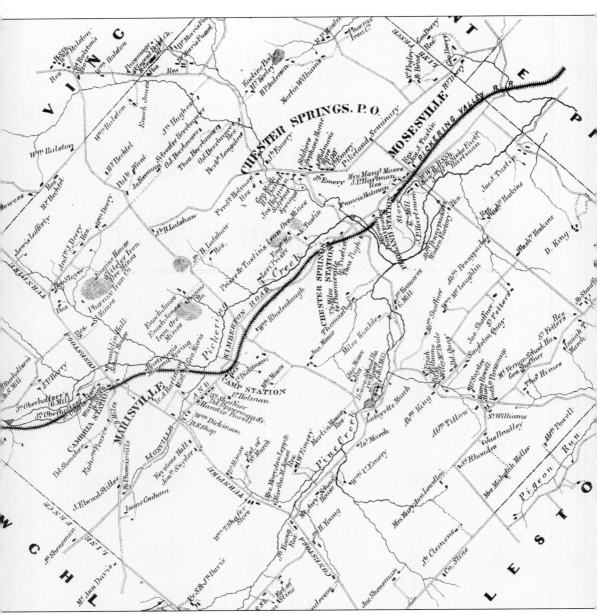

This 1873 map of West Pikeland Township from A. R. Witmer's *Atlas of Chester County, Pennsylvania*, shows Chester Springs, formerly known as Yellow Springs, in the upper section. During this time period, the village was home to the Chester Springs Soldiers' Orphan School. See page 55 for more details.

On the cover: Please see page 65. Note that this image was reversed for cover design. (Courtesy of Historic Yellow Springs Archives.)

IMAGES
of America

YELLOW SPRINGS

Rob Lukens and Sandra S. Momyer
for Historic Yellow Springs

ARCADIA
PUBLISHING

Published by Arcadia Publishing
Charleston SC, Chicago IL, Portsmouth NH, San Francisco CA

Printed in the United States of America

Library of Congress Catalog Card Number: 2007922524

For all general information contact Arcadia Publishing at:
Telephone 843-853-2070
Fax 843-853-0044
E-mail sales@arcadiapublishing.com
For customer service and orders:
Toll-Free 1-888-313-2665

Visit us on the Internet at www.arcadiapublishing.com

*To all of the courageous people who have stepped through
these doors, walked down these pathways, and left
their legacy at this remarkable place.*

CONTENTS

Acknowledgments

Just as it has been the people who have defined the amazing history of Yellow Springs, so, too, have many people been integral in weaving together this important story.

We want to thank Penny Balkin Bach, Robert Creswell, Michael Fiorillo, Jack Gerber, Jan Hall, Harold Hallman Jr., Michael Ioccoca, Dr. and Mrs. Henry A. Jordan, Alice and David Lane, Chester C. Marron, Roland Maynard, Katharine Ann Vail McCreary, Charles McManus, Robert K. Momyer, David J. Monteith, James O. Moore, the Bodo Otto Family Association, May Pitman Piccioni, Roberta Rometsch, Elisabeth Speight, Ida Geyler Tollenger, Doris "Dorcas" Kunzie Weidner, Marilyn and Roswell Weidner, and Lucy Woodland for providing photographs and sharing stories.

We are indebted to the Pennsylvania Academy of the Fine Arts for their support of this project. Thanks also to Cliff Parker and Laurie Rofini at the Chester County Archives; Ellen Endslow, Pam Powell, and Diane Rofini at the Chester County Historical Society; R. A. Friedman at the Historical Society of Pennsylvania; Pastor Fred Opalinski of the Historic Trinity Lutheran Church in Reading; and Abby Gala at the People's Light and Theatre Company.

Thank you to Priscilla A. Waggoner, Ph.D., for her extensive and heartfelt research on the eras of Yellow Springs. Also, this book would not be possible without the magnificent photographs of Vince Spangler (1914–1990). Spangler was a photographer and cameraman for Good News Productions and took most of the early Historic Yellow Springs photographs. Jean Yeaworth, who worked closely with her late husband Irvin Shortess "Shorty" Yeaworth (1926–2004) at Good News Productions, and her family remain a valued resource. We thank Kirsten DeLapp for computer support.

Last, but not least, our immense thanks and appreciation goes to Meg Randall. Meg worked closely with us helping to select images and worked tirelessly as our chief scanner for the project. Readers would not be enjoying this book without her loyalty and devotion to the project.

For us, it has been the ultimate joy to work together to tell the story. We share the deep love and affection for the people, the place, and the preservation of Yellow Springs.

All images used in this book are from the Historic Yellow Springs (HYS) Archives unless noted otherwise. For more information regarding the history of the village of Yellow Springs, please contact Historic Yellow Springs, Inc. at P.O. Box 62, 1685 Art School Road, Chester Springs, Pennsylvania 19425; by telephone at (610) 827-7414; by e-mail at inquiries@yellowsprings.org; or visit our web site at www.yellowsprings.org.

INTRODUCTION

While the eye is in every direction delighted, within the circumference of a smaller circle, with highly cultivated farms, large and commodious houses, hanging, as it were, upon the declivities of mountains, or seated in the midst of verdant dells . . . with the various tints of vivid green interspersed with rich and diversified fields of grain . . . which form a perfection of landscape calculated to gratify the most fastidious taste, and to amuse and charm the most capricious and glowing imagination.

—"A Description of the Yellow Springs in Pennsylvania," *Port Folio*, 1810.

This is an illustrated story of a unique place. Yellow Springs is a living village steeped in such distinguished history, tradition, and folklore that it stirs the imagination of those who visit. The village spans over 275 years of American history. As the vision of this unique place unfolds before you, you will see how the "perfection of landscape" was critical and became the background—the common thread woven throughout the centuries—that entwined the people and events and provided the beauty and enchantment we enjoy today.

The value of the historic buildings would be greatly diminished if considered out of the context of their natural environment. It is the blending of the buildings and nature, enhanced by the historic associations that afford a lasting impression of Yellow Springs. This book tells the story of the people, the places, and the blending with the landscape that presents such a compelling spot.

Yellow Springs presents the history of several distinct eras to both explain the changes in the village over time and illuminate the fact that much has stayed the same. Instead of flowing into one another, each of these eras stops abruptly when a new era begins. Each has different stories, people, and events set against a nearly timeless landscape.

The story of Yellow Springs begins in 1681, when William Penn arrived in the new world with a land grant from King Charles II of England. He made treaties with the peace-loving Native Americans that were settled here. Archeological and historical evidence suggests that the Lenape Indians knew of the bubbling springs. According to local tradition, they called it the "yellow waters" and utilized the magical springs for their medicine.

It was here that the Welch, Germans, and English began to settle the area with its rich landscape of fertile soil and abundant water. They also learned of the healing springs. As word of the magical waters reached Philadelphia, a stream of visitors made their way west to partake of the medicinal qualities offered by the Yellow Springs.

American colonists brought with them a history of mineral waters used in Europe. Not wanting to lose this source of health and pleasure, they sought the mineral waters. By 1722, Yellow Springs was mentioned in a Philadelphia newspaper. By 1750, roads into the springs were being constructed and Robert Prichard petitioned to accommodate the visitors arriving here by building a tavern. The waters were used for drinking and bathing and, combined with the beautiful surroundings, became very popular.

The Revolutionary War ceased operations of the health spa. In September 1777, Gen. George Washington established temporary headquarters at the Yellow Springs Plantation. Upon establishment of the winter camp at Valley Forge in 1777 and 1778, Washington oversaw the building of a medical facility there to improve health conditions for his army. With dedicated doctors, medical practices were greatly improved. Local residents supported the fight for freedom. As a result, the Continental army marched from Valley Forge both as a major military force and with an organized medical department.

In 1783, the Yellow Springs spa reopened as a fashionable resort. In addition to the springs, the winding creek and the shaded trails of the landscape added to the romance and pleasure afforded there. Guests enjoyed "the salubrity of the air, the purity of the water, the coldness and clearness of the bath, the fertility of the soil, and the variegated scenery which surrounds it." Visitors ranged from the prominent dignitaries from Philadelphia and beyond seeking to exhibit their financial and political status to those seeking cures for their ills. Innkeepers rallied to bring high standards to the spa experience. However, with increased knowledge of medicine and health, Yellow Springs' favor dwindled. All spa activities ceased when the Civil War erupted in 1861.

With the large and commodious buildings and the open meadows, this seemed a likely place for the Commonwealth of Pennsylvania to establish one of its Pennsylvania Soldiers' Orphan Schools for orphans of soldiers killed or maimed during the Civil War. Now it was the children who populated the village as they found refuge and enjoyed an educational experience. Parade grounds and play areas filled the landscape until the need for orphanages diminished and the school closed in 1912.

In 1916, the landscape was again recognized for its beauty plus its painterly qualities and the education was geared towards the artistic realm. The Pennsylvania Academy of the Fine Arts purchased the entire village and established a country school to "enjoy fine art in the open air, with all the beautiful surroundings of Nature itself." The landscape and the natural beauty of the area were key and teachers and students gathered to interpret it each in their own way. When the trend of art shifted to the abstract form in the 1950s, the school closed and classes remained solely in the city school in Philadelphia.

In 1952, a filmmaking company recognized the artistic qualities of the village landscape, and the creative process continued. Good News Productions produced Christian education films and believed the landscape could provide the proper backdrop for their productions. A community of Christian people moved to the village and once again utilized the buildings for working and communal living, sharing what they had and what they earned.

When the film company posted a "for sale" sign on the property, local residents, headed by Cornelia D. Fraley, worked to purchase it in 1974. To Fraley and a grassroots group of volunteers, the village was too important to be developed or bulldozed. They worked to have the property listed on the National Register of Historic Places and created non-profit organizations to carry on historic preservation and artistic creativity in the village.

Today the village continues to reinvent itself. Always relying on the value of the land and the architectural integrity of the historic structures, life continues now and will into the future. We invite you to relive the grandeur, romance, and magic of Yellow Springs as you learn about the people and events in the village and the energy and promise of years to come.

We are pleased to share this saga of discovery, medical advancement, rejuvenation of the body, generous love and humanity, artistic splendor, and creative endeavors. This "perfection of landscape" has been and will continue to be the gathering place for people of vision. It is a true treasure to be cherished.

One

THE FIRST 150 YEARS

It is a melancholy Truth that our Hospital Stores are exceedingly scanty and deficient in every instance. Our difficulties and distress are certainly great and such as wound the feelings of Humanity.

—General George Washington, 1777

Like every other story of Pennsylvania's past, the story of Yellow Springs begins with William Penn. Penn, who founded Pennsylvania in 1681, granted 30,000 acres of land to Mathias Vincent in northern Chester County. Vincent then sold 10,116 acres to Joseph Pike, giving the area's name "Pike's Land." Before settlement, oral tradition and archeological investigations suggest the Lenape Indians occupied the area around the springs. As word of the springs reached Philadelphia, a stream of visitors made their way there to partake of the waters.

Based on the medical knowledge of their time, settlers sought the waters for their purported medicinal qualities. Roadways were constructed and Robert Prichard established the first tavern to accommodate these travelers. The colonial spa thrived until the Revolutionary War came to Chester County.

By 1777, the Revolutionary War was raging in Chester County. Gen. George Washington used the Yellow Springs Tavern to set up temporary headquarters on September 17, 1777. He apprised the Continental Congress of his position and condition via letters from the Yellow Springs.

With the Valley Forge encampment of 1777–1778 and increasing death from illness, Washington petitioned the Continental Congress and gained permission to build a hospital at Yellow Springs. At that point, colonial medicine was primitive at best, but military medicine was without precedent. The Yellow Springs Hospital provided improved health care and served as the medical department headquarters for the middle district until 1781.

By 1783, the Yellow Springs health spa reemerged as a fashionable resort known for its healthful qualities and social scene. In the early 19th century, a series of owners operated the spa property in a variety of hotels, cottages, and springhouses. Packet boats and stagecoaches brought people to the springs from Philadelphia to take the waters and enjoy lectures, concerts, dances, and parties. With advances in medicine and the rise of Victorian propriety, the buildings of Yellow Springs closed their doors as a spa resort in the mid-19th century.

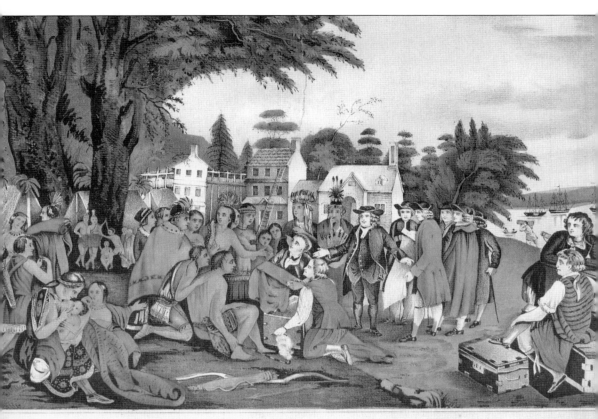

PENN'S TREATY with the INDIANS when he founded the PROVINCE of PENNSYL* 16!
THE ONLY TREATY THAT NEVER WAS BROKEN.
Published by James Baillie 87th S.t near 3.rd Avenue N.Y.

For centuries, local tradition held that the Lenape Indians were the first to use and name the iron springs at "Yellow Springs." Recent archeological evidence suggests that Lenape Indians once occupied the site around the springs and archaeological documentation of other tribes indicates that they may have used the springs for medicinal or ceremonial purposes. Although it is unclear if any natives remained in the area when settlers arrived at the springs, Lenape-settler relations were generally friendly across southeastern Pennsylvania. The natives helped early settlers with clearing the land and introduced them to new crops. Benjamin West's timeless painting *Penn's Treaty with the Indians* allegorically captured these peaceful relations. This 19th-century print of West's original 1771 work depicts Penn's Treaty of 1682, although there is no documentation of this exact event. (Courtesy of the Chester County Historical Society, West Chester, PA.)

The village of Yellow Springs first appears in historical documentation as early as 1722, when the *Philadelphia Mercury* noted a "new bath or mineral water found in the Great Valley." This reference makes Yellow Springs perhaps the oldest known spa in Colonial North America. The earliest documentation of a tavern in the village dates to 1750, when Robert Prichard petitioned the local courts for a "publick house of entertainment." This original structure operated as an inn for nearly 100 years, forming the basis for a thriving spa resort based in the village. According to Philadelphia newspapers, people traveled from as far away as the West Indies and the village hosted 400 to 600 people per day before the American Revolution. Travelers came to escape the city heat and stench, while consuming and bathing in the iron-rich waters that purportedly improved one's health. No imagery of the village survives from this early era. (Courtesy of the Chester County Archives.)

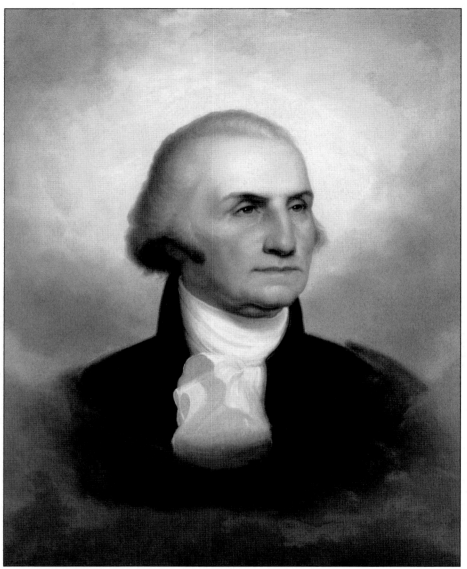

Following the Battle of the Brandywine on September 11, 1777, Gen. George Washington retreated through Chester to Philadelphia and eventually to Germantown. He soon returned to the Great Valley where he met British troops on September 16 around modern day West Goshen and East Whiteland Townships. When troops were on the verge of full engagement, the skies opened up, drenching the troops' weapons and ending what came to be known as the Battle of the Clouds. On September 17, Washington stopped at Yellow Springs on his way to Warwick Furnace to replenish his munitions. He stayed in the original 1750 inn while Continental army troops camped on the surrounding hillsides. Washington wrote several letters to the Continental Congress from Yellow Springs, which he termed the "Yellow Springs Plantation." In one, he stated "We suffered much from the severe weather yesterday and last night, being separated from our tents and baggage, which not only endangers the health of the men, but has been very injurious to our arms and ammunition." This portrait of Washington is attributed to Rembrandt Peale. (Courtesy of the Chester County Historical Society, West Chester, PA.)

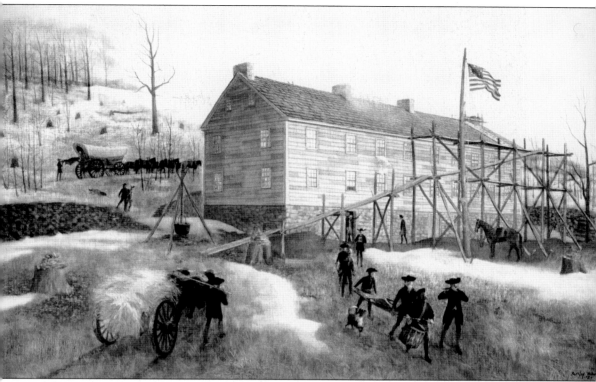

After troops marched into Valley Forge on December 19, 1777, Washington urged Congress to improve the army's medical department or the war would be lost. Washington, who was already familiar with the Yellow Springs site from his September 17 visit, commissioned the first permanent military hospital in North America to be built in the village. Dr. Samuel Kennedy, owner of the land and enlisted surgeon with Gen. Anthony Wayne, loaned land for the hospital to be built to service sick and wounded soldiers at Valley Forge. Construction began in December 1777 and ended in January 1778. Kennedy also oversaw the operations of the Yellow Springs hospital, although he owned a farm off site in East Whiteland Township. In June 1778, Kennedy caught typhoid fever from his patients and died within a few days. This 1975 rendering of the structure is by Chester County artist Barclay Rubincam. (Courtesy of Dr. and Mrs. Henry A. Jordan.)

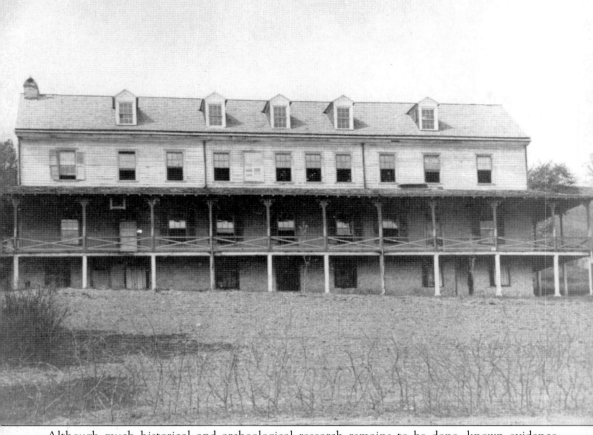

Although much historical and archeological research remains to be done, known evidence suggests that local residents were involved in the hospital's operations. Local man and Continental soldier Maj. Peter Hartman gathered food and clothing from local farmers and took them to Valley Forge. Upon returning, he transported sick soldiers to the hospital in his wagon. Abigail Hartman Rice was a nurse at the hospital and contracted deadly typhus from her work. Christina Hench was a nurse as well and lived nearby on a 300-acre farm. George Washington visited the hospital several times and was very pleased with its operation. He returned to the hospital again before the march out of Valley Forge and bid farewell to the soldiers who stayed behind. An August 10, 1778, report stated that 124 out of 725 soldiers that stayed there died. No one knows where those soldiers were buried. This photograph was donated to the HYS Archives by Alice and David Lane.

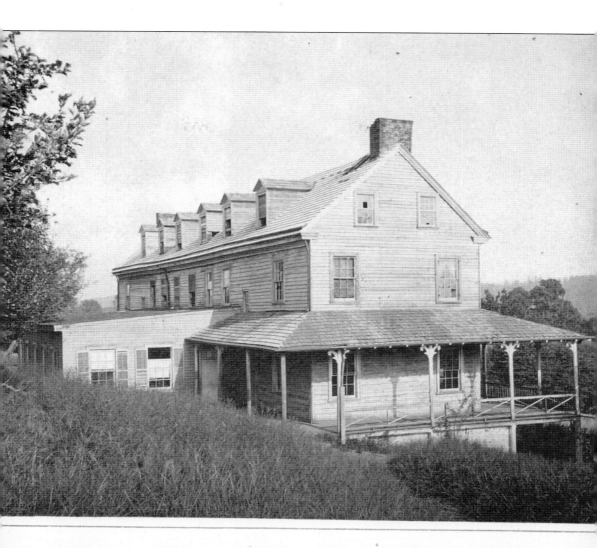

Revolutionary Hospital

Yellow Springs –

The Yellow Springs hospital was known for its state-of-the-art construction and maintenance. Its dimensions were sizeable, standing at 106 feet long and 36 feet wide with three full stories and an attic. Nine-foot-high porches wrapped around the first two stories on three sides. The first (ground) floor had a kitchen, dining room, and utilitarian quarters. The second floor was divided into two large wards for patients while the third contained several smaller rooms. In addition to its patient care facilities, this building and its staff also served as the Middle District of the Medical Department headquarters. Washington regularly ordered his physicians to fill their medicine chests at the Yellow Springs Hospital. Since 1987, the Herb Society of America Philadelphia Unit has maintained a recreation of an 18th-century medicinal herb garden on the hospital site. The original of this image is a cyanotype, dating from around 1880 to 1900. (Courtesy of the Historical Society of Pennsylvania, Stauffer Collection.)

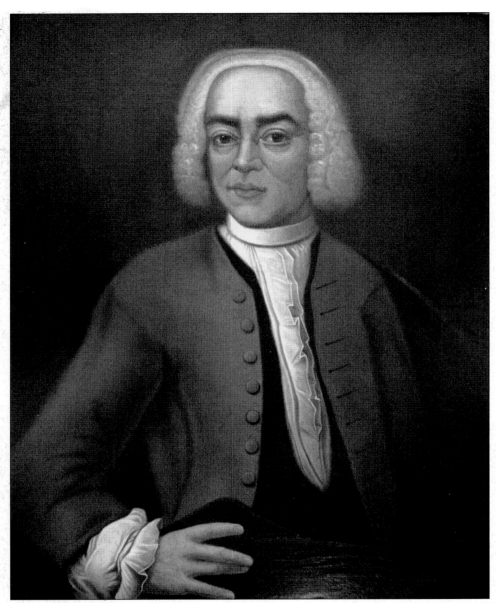

Dr. Bodo Otto was born in 1711 in Hanover, Germany, and immigrated to Philadelphia in 1755 to practice medicine. He later moved to New Jersey and then onto Reading where he enlisted at the age of 65 as a senior surgeon of the Continental army. In spring of 1778, he was charged with running the hospital at Yellow Springs including inoculations and treatment of disease. Otto's three sons assisted him in his duties. Although the hospital facilities were considered state of the art for their time, by spring 1780, Otto complained to Gen. George Washington that the physicians "complain daily, they have not received any Money for their Services these Seven Months past, neither are they washed with Cloathing . . . The Nurses & Orderlies refuse serving any longer, as they receive no pay . . . the Sick and Wounded must unavoidably suffer." When the hospital closed in 1781, Otto returned to Reading where he commenced his private practice. (Courtesy of Historic Trinity Lutheran Church.)

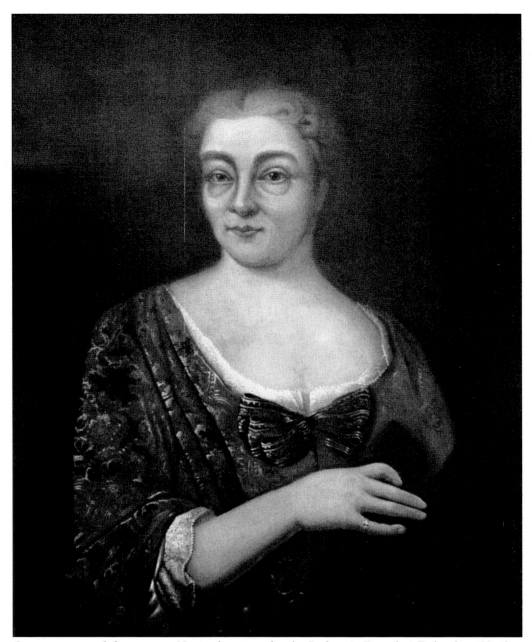

Otto was married three times. Here is his second wife, Catherina Dorothea Dahncken. His first wife, Elizabeth Sanchen, whom he married in 1736 in Germany, died just two years later. In 1742, he married his second wife in Germany and she bore him four children, three of which survived into adulthood. Dahncken and their three sons made the long trip across the Atlantic Ocean with Otto in 1755 on the ship *Neptune* and settled in Germantown in Philadelphia. Dahncken died in 1765 when the family was living in New Jersey. In 1766, Otto married Maria Margaretta Paris, an English woman. (Courtesy of Historic Trinity Lutheran Church.)

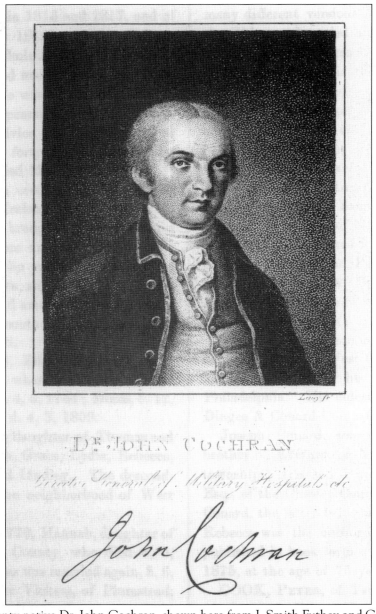

Dr. JOHN COCHRAN

Director General of Military Hospitals etc

John Cochran

Chester County native Dr. John Cochran, shown here from J. Smith Futhey and Gilbert Cope's 1881 *History of Chester County*, was a physician and surgeon general of military hospitals. He and Dr. William Shippen, director general of military hospitals, proposed that they plan a hospital modeled after the British. At Valley Forge, Cochran was charged with caring for those at the encampment. Under Gen. George Washington's orders, they erected "flying hospitals" at Valley Forge, which were temporary hospital huts for each brigade. Through the winter and spring of 1778, these hospitals swelled at the encampment to 3,800 soldiers, much due to the smallpox inoculation prescribed for the troops. Near Valley Forge, the army made hospitals out of schoolhouses, churches, homes, and any other structures that could be used. Only the sickest patients were sent to Yellow Springs, which housed 125 patients at a time.

Following the American Revolution, Yellow Springs reemerged again as a spa resort. These 1810 engravings from the publication *Port Folio* may be the earliest views of Yellow Springs. In the above print, the perspective is from the west looking east towards the original 1750 inn. The bottom perspective looks south from behind the hospital building. As an accompanying article explained, "Of the various watering places and rural retreats which invite the languid, the listless, or the laborious citizen to invigorate his system, to relax from the fatigues of business, or to restore his declining health, none certainly combines so many advantages as this delightful spot." (Above, courtesy of the Chester County Historical Society; below, courtesy of the Historical Society of Pennsylvania.)

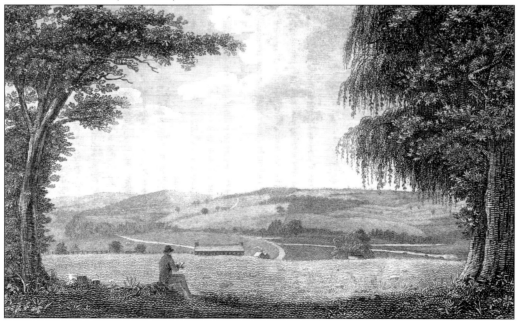

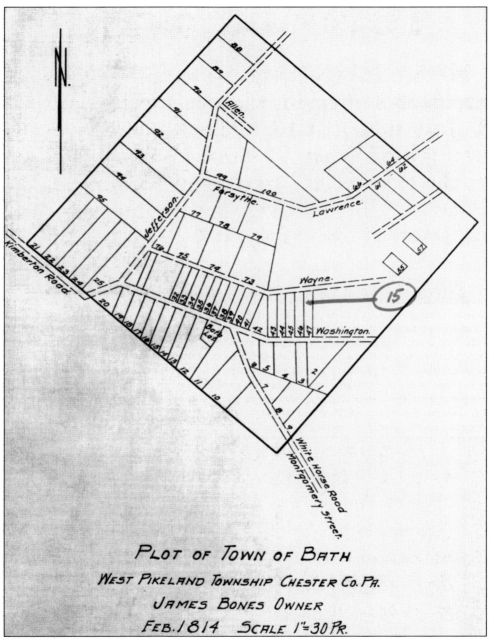

PLOT OF TOWN OF BATH

WEST PIKELAND TOWNSHIP CHESTER CO. PA.

JAMES BONES OWNER

FEB. 1814 SCALE 1"=30 PR.

In 1814, the owner of the Yellow Springs property, Col. James Bones, changed the village's name to Town of Bath and attempted to sell 100 housing lots. Lots differed in size, with some including existing structures while others were heavily wooded. Each lot cost $250, a price that included common use of the spring facilities for all deed holders. Some lots that incorporated existing structures sold for as much as $6,000, including a "mansion house" (hotel), "large and commodious frame building" (old hospital), stone barn, stables, ice house, smokehouse, and springhouses. Bones planned to carve new roads into the hillsides, provide new amenities, and essentially create a brand new town in the hills and valleys around Pickering Creek.

TOWN OF *BATH.*

Notice is hereby given to the holders of certificates therein, that on the second day of July next, at 11 o'clock, A. M. in the borough of West-Chester, in Chester county, the situation of the lots of holders of certificates will be determined according to the original plan of the town.

<div align="right">

James Bones.

</div>

June 4th, 1814. 46—4t. *

This June 1814 newspaper listing (above) and certificate (below) indicate the extent of Bones's real estate dreams for the village of Yellow Springs, to be renamed as Town of Bath. In that month, four months after he initially began the sale of properties, Bones was already arranging the layout of the town according to the number of lots sold. His statement that "a few certificates yet remain unsold" was probably a bit of a sales pitch. With less than half of the lots actually sold, Bones's plans never materialized and the Town of Bath became a speculator's unrealized dream. Bones put the Yellow Springs hotel up for sale in 1815 but reopened it in 1820. Despite his failure as a real estate speculator, he successfully operated this, the original hotel building, until 1838. (Courtesy of the Chester County Historical Society, West Chester, PA.)

THE owner of this Certificate, is entitled to a LOT in the town of *Bath,* the situation of which is to be determined by Lot, (agreeably to the original Plan and Scheme of the said town,) for the sum of *Two Hundred and fifty Dollars.* The subscriber obligates himself to make a clear title in fee simple, to the holder of this Certificate, in fifteen days after the drawing for the Lots.

Yellow-Springs, Feb. 18, 1814.

James Bones

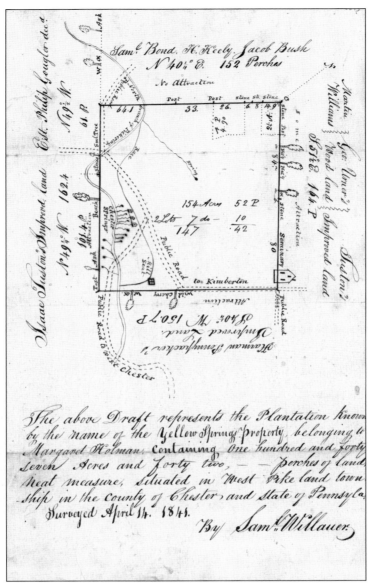

This April 14, 1841, draft of the Yellow Springs property provides a snapshot of it. As early as 1806, Col. James Bones promoted the Yellow Springs spa. Margaret Holman became a second innkeeper nearby in 1821 and a competition arose between them. Bones had summerhouses built on the hillside and operated the old hotel. Holman boasted 50 lodging rooms, two dining rooms, and several parlors. By 1823, she operated a three-floor facility for those who sought peace and quiet, in contrast to Bones's lodging, which attracted a livelier crowd. In 1835, the *National Gazette* reported, "The old animosity between the two houses, much to the credit of both, appears to have subsided. It is a remarkable fact that the drivers and agents of the opposition coaches, from the railroad over, get along without exchanging a single shot." The coaches competed to get their passengers to the springs first to secure the best accommodations. By 1838, Holman bought out Bones's interest and owned the entire village. (Courtesy of the Chester County Historical Society, West Chester, PA.)

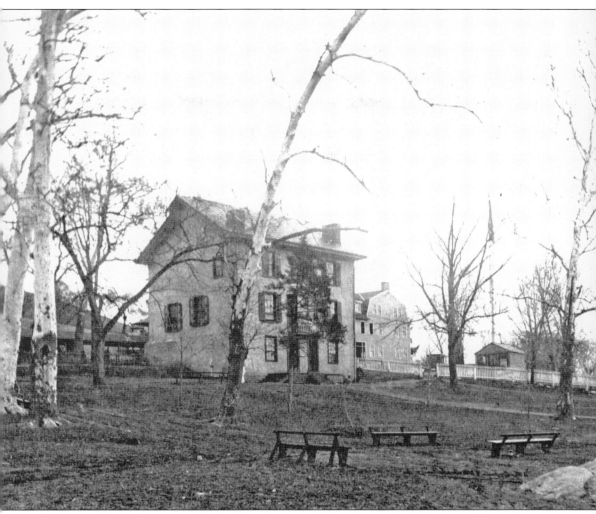

This image shows the rear of the building historically known as Our House, and later, Main House. Our House served as the innkeeper's home during the spa era. Although most of the building was constructed in the early 19th century, the ground floor is colonial with a walk-in fireplace. This 1900 photograph shows the building before a porch structure was added onto the back. Pathways led to the springs below. In 1827, the name of the village was changed to Chester Springs in order to avoid confusion over a second Yellow Springs that existed in Blair County. Historically, however, the name Yellow Springs has stuck with the village. (Courtesy of the Chester County Historical Society, West Chester, PA.)

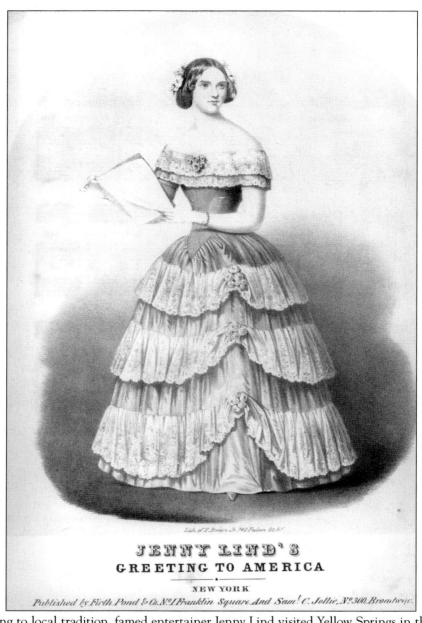

JENNY LIND'S
GREETING TO AMERICA
———— • ————
NEW YORK
Published by Firth Pond & Co. No. 1 Franklin Square And Sam. C. Jollie, No. 300 Broadway.

According to local tradition, famed entertainer Jenny Lind visited Yellow Springs in the 1850s to recover from laryngitis and performed during her stay. Two village buildings, the Jenny Lind House and the Jenny Lind Springhouse, carry her name in memory of this visit. No historical documentation has ever surfaced to confirm this visit, but archival research still remains to be done in this area. This particular image is the cover of the 1850 sheet music for "Greeting to America," Lind's greeting to America, written by Bayard Thomas Esquire with music composed by her accompanist, Julius Benedict. Before Lind came to the United States from Sweden, P. T. Barnum held a contest with a $200 prize for the best new song written for her. Thomas won the contest with "Greeting to America" and fierce competition arose among music publishers who all wanted to produce the songbook.

Among the many famous entertainers who performed at Yellow Springs were Chang and Eng Bunker, the original Siamese twins. Yellow Springs was one of their many stops as they toured through Chester County in 1836, which included visits to West Chester, Downingtown, and Phoenixville. In an era before the expansion of railroads, there were two main methods for reaching Yellow Springs. Travelers rode stagecoaches directly from Philadelphia, as seen below, or took packet boats up the Schuylkill Canal from the city to Norristown, where they caught stagecoaches to their final destination. Along the way, guests might enjoy breakfast at Manayunk and dinner at Mrs. Webb's in Norristown. The advertisement below appeared in the *Norristown Herald and Weekly Advertiser*. (Right, courtesy of the Chester County Historical Society.)

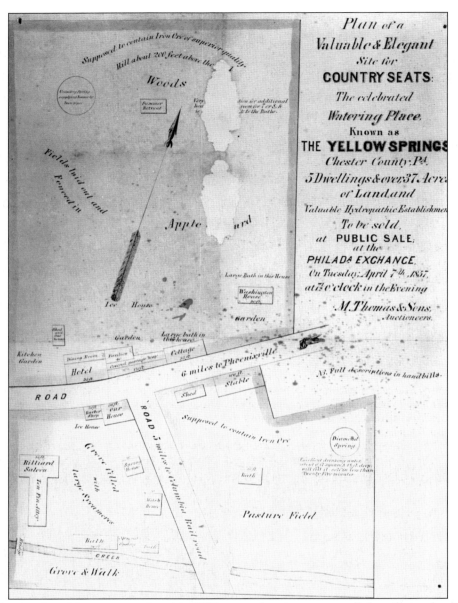

Plan of a
Valuable & Elegant
Site for
COUNTRY SEATS:
The celebrated
Watering Place,
Known as
THE YELLOW SPRINGS
Chester County; P.A.
5 Dwellings & over 37. Acres
of Land, and
Valuable Hydropathic Establishment
To be sold,
at PUBLIC SALE,
at the
PHILAD.ª EXCHANGE,
On Tuesday; April 7.ᵗʰ 1857,
at 7 o'clock in the Evening
M. Thomas & Sons,
Auctioneers.

By the time that this map was printed in 1857 as an advertisement to sell the village, the village was already in decline and the spa business defunct. However, many vestiges of the resort's golden era remained, as marked on the map. In the early to mid-19th century, Yellow Springs had a post office and, for a short while, its own newspaper called the *Literary Casket and General Intelligencer*. Many other structures that have since disappeared are also listed on the map, including a billiard hall, a bowling alley, a barbershop, several springhouses, several outbuildings, and a summer retreat on top of the hill. Margaret Holman spearheaded local efforts to explore the "propriety of making a railroad from the Yellow Springs to intersect the Pennsylvania Railroad at the most eligible point on a direction to Philadelphia." The railroad was completed in 1842 but the branch to Yellow Springs was not constructed until 1873. Thus train passengers from Philadelphia still relied on coaches from train stations in Norristown and Phoenixville to get to the springs.

26

MILLINERY.

MRS. P. A. DEERY respectfully informs her friends and the public in general, that she continues to carry on the Millinery business,

At the Yellow Springs.

She intends to keep on hand all sorts of Fall and Winter trimmings, such as Ribbons, Artificials, Flowers and Feathers of all kinds; and an extensive variety of Fancy articles. Thankful for past favors, she respectfully invites a call from those desiring any article in her line of business.

Sep 21—3t

N. B. She also intends to keep on hand Ready-made CLOAKS for Ladies.

As these advertisements for P. A. Deery's millinery and Anthony Olwine's store indicate, the village of Yellow Springs grew into a bustling crossroads in the early 19th century with many of the businesses and conveniences of larger towns. Coach maker Phillip Gougler worked his craft nearby and an ice cream shop was situated in the center of the village as well. There was a sawmill and 25 acres of wheat on the property. Guests at the hotel could ride horses. For the sportsmen, the fishing and fowling were said to be excellent. (Courtesy of the Chester County Historical Society, West Chester, PA.)

since he commenced business at the Yellow Springs, and now offers a general and well selected assortment of

British, French, India and Domestic goods,

CONSISTING OF

Superfine and common Cloths,	Gloves,
Do. Cassimeres,	Sewing Silk, &c.
6-4 and 7-8 Cambric muslins,	Domestic plaids,
4-4 do. do.	Domestic stripe,
Shirting do.	Domestic Chambray,
Drillings,	Checks,
Wilmington Stripes,	Shirtings,
Ginghams, calicoes,	Sheetings,
Bombazetts, Hosiery, &c.	Cotton yarn, &c.
Flag Handkerchiefs,	Groceries,
Black Silk ditto,	Wines and Liquors,
Figured do.	China Glass and Queensware
Book muslin do.	Drugs, Paints and Dye stuffs,
Blue Nankeens,	Ironmongery in its variety,
Yellow ditto,	Mackeral by the Barrel, or half barrel.

With a full assortment of other articles which he dont think it necessary to mention. He hopes by industry and strict attention to business, and by offering his goods at the lowest price for cash or produce, to merit a continuation of public favor.

Anthony W. Olwine.

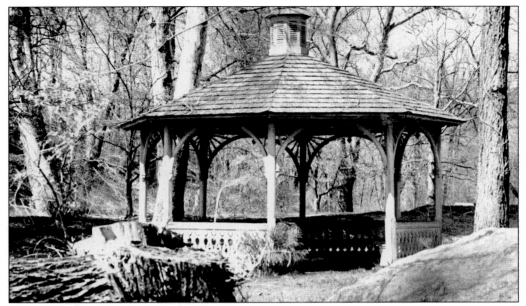

This 1950s or 1960s photograph, taken by Wayne E. Homan, clearly shows the gazebo built around 1839. The gazebo holds the iron spring in a central well. Up until the early 19th century, the iron water was the only mineral water known on the Yellow Springs property. Several other iron springs flowed at different locations in the village, with a variety of bathing houses. (Courtesy of the Chester County Historical Society, West Chester, PA.)

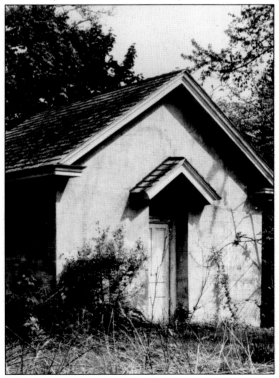

Built in the early 19th century, the so-called Jenny Lind Springhouse housed the property's sulfur springs. Before the visit of Jenny Lind, the structure was known as the Sycamore Spring. According to the book *Springs and Spas of Old-Time Philadelphia*, there was a trapeze-type of contraption that allowed one to take a "swinging plunge" through the water. (Courtesy of the Vince Spangler Collection, HYS Archives.)

In an era of extreme modesty, guests were required to wear bathing clothing that would be considered quite awkward by modern standards. This early- to mid-20th-century drawing by a Miss Hunsiger of the University of Pennsylvania library is a rendering of what a women's bathing outfit at Yellow Springs would have looked like at around 1845. Hunsiger based her drawing on historical records.

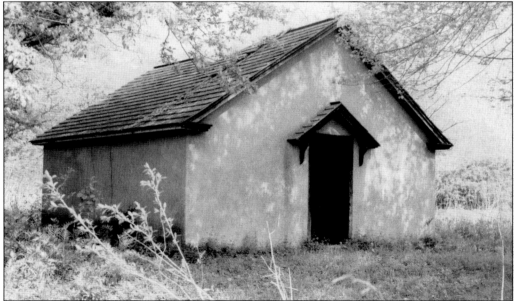

This image shows a more modern view of the Crystal Diamond Springhouse, a structure built in 1846 to house magnesium-rich spring waters. In 1845, Dr. George Lingden owned and operated the property as a hydropathic treatment center. Lingden's wife gave this spring the moniker "Crystal Diamond" because small bubbles rose from the well's bottom to the surface, which looked like small diamonds in the water. (Courtesy of the Vince Spangler Collection, HYS Archives.)

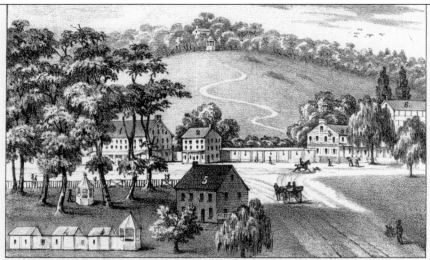

1 Hotel,
2 Hall,
3 Cottage,
4 Baths and
Fountain,

5 Our House,
6 Barracks,
7 Mountain
House, Spring.
8 Piazzas 500 ft.
in length.

YELLOW SPRINGS, OR CHESTER SPRINGS,

CHESTER COUNTY, PENNSYLVANIA, 32 MILES FROM PHILA.

THIS Watering Place will be ready to receive visitors after the Fifteenth of May, Inst. The Proprietor having added a spacious dining room, and otherwise enlarged and improved his Establishment, has also engaged an experienced gentleman as Superintendent, and secured the services of the best cooks, Confectioners and Servants, by which efforts he hopes to render his Establishment both agreeable and stylish.

This place, so long celebrated for its Chalybeate Baths, unrivalled in the cure of Chronic Disease, was selected by General Washington as an Army Station, for its healthfulness and beauty, and teems with historical recollections. It is Dr. Lingen's intention, after the first of September to appropriate part of the Establishment (which will be open during the whole year) to patients under Homeopathic or Hydropathic treatment, the variety of waters being eminently adapted to the latter purpose. Besides being a Post Office station, there are facilities for arrival and departure twice a day by the Reading, Columbia and Norristown Rail Roads. Letters to the Proprietor (post paid) are to be addressed to

DR. GEORGE LINGEN,
Chester Springs, Chester Co., Pa.

This 1846 broadside advertised the establishment of a hospital for water cures at Yellow Springs. In 1845, Dr. George Lingen purchased the property from Margaret Holman and established a center for hydropathic treatment around the springs. In a letter dated 1847, a patient named John Knight described his treatment to his wife: "As usual I was 'packed' in wet sheets early this morning for about two hours, when I perspired freely, under the warm influences of sundry blankets, comforts and a feather bed all pressed and squeezed tight and close around me. Upon rising, or rather upon being raised up from this vapour bath, I walk to a deep very cold plunge bath,—when I suddenly am stripped of my blankets, and then instantly jump into the water, head foremost;—and then take one or more plunges and then step out and I am rubbed well and thoroughly dry and warm. Then I dress and walk a mile or so back—in the mean time drinking a glass of cold water every half hour until within an hour of breakfast time."

Two

THE CHESTER SPRINGS SOLDIERS' ORPHAN SCHOOL

If men fall on the battle-field or in the discharge of the duties which they owe to the nation . . . a loving and God-fearing people will take their offspring to themselves as their own, and, so far as can be, fit them physically, mentally, and morally for the stern realities of this world and the enjoyments of that which lies beyond.

—Col. James L. Paul, chief clerk, Orphan School Department of Pennsylvania

After Andrew Gregg Curtin was elected governor of the Commonwealth of Pennsylvania in 1861, his sense of duty during the Civil War bestowed him with the title "Soldiers' Friend." After witnessing two Civil War orphan children begging for bread at his door, he approached the Commonwealth's house of representatives to fund a program to assist all such children.

A state act of 1864, supported with $50,000 from the Pennsylvania Railroad, created the state's orphan school system. The program cared for Pennsylvania's children under the age of 16 who depended on public charity and their impoverished mothers or guardians caused by the death of the children's fathers.

By December 1865, the system established eight schools for older children (ages 10 to 16) and 17 homes for younger children. When the Chester Springs Soldiers' Orphan School opened in 1869, it was owned by a stock company and filled with children transferred from the existing Quakertown and Paradise schools.

The old spa buildings became the students' campus. The "Cottage" (now the Lincoln Building) was the girls' and female faculty facilities with a common library and music room. Boys and male faculty lived in the "Hotel," now part of the Washington Building, which also housed the dining area. Other portions of the property held a sewing room, infirmary, schoolhouse, chapel, laundry facility, and farm outbuildings. Here uniformed children followed strict daily schedules with a military-like structure that was designed to raise their academic, moral, and physical attributes.

The Chester Springs school closed in 1912 as the need for orphan schools declined. The children in residence were sent to the Scotland school which functions today as the only school remaining from the original system.

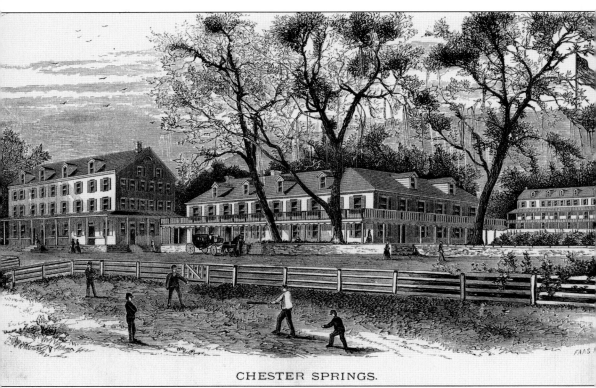

CHESTER SPRINGS.

Concerns about the care for children of Civil War soldiers arose as early as 1862, soon after the first shots of the Civil War rang out. In 1864, Pennsylvania's governor, Andrew Gregg Curtin, appointed former secretary of the Commonwealth Thomas H. Burrowes, as the superintendent of soldiers' orphans to devise a plan for caring for these children. The state limited its program to children of Pennsylvania under the age of 16, who were dependent on public charity or impoverished mothers or guardians. An act of 1864 created a statewide school system that included 44 schools, homes, and asylums. The Chester Springs school was organized in 1868 and opened in 1869. The first children to attend were transferred from Quakertown and Paradise schools. This engraving appeared in early annual reports for the school system.

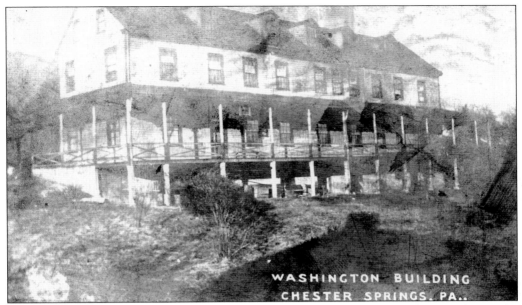

This postcard image, erroneously entitled "Washington Building," actually shows the Revolutionary War hospital structure that served as classrooms and a chapel. On May 4, 1902, a student named Joseph Cripps took a dictionary, tore it into shreds, and ignited it in a closet. The schoolboys started a bucket brigade to extinguish the fire, but with little impact. Cripps later admitted starting the fire, and the school quickly rebuilt the structure.

This image shows the new hospital building erected to replace the original structure after the 1902 fire. When rebuilt by P. E. Jefferis of West Chester, the building was 50 feet wide by 80 feet long, and set on the original foundation. A general assembly room occupied the first floor and seven classrooms were on the second floor.

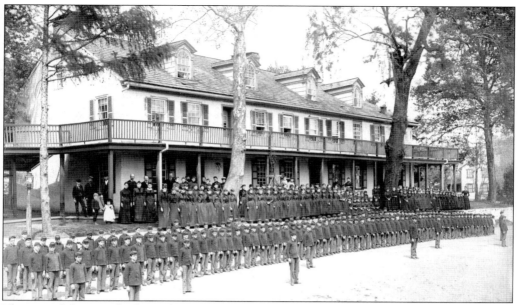

This pair of photographs shows the Lincoln Building both before (above) and after (below) the 1899 fire. Originally built as an inn in the early 19th century, the Lincoln Building housed the girls and contained a sitting room, wash and bathing rooms, a library for both boys and girls, and a music room. The library was established in 1892 with 500 volumes and opened on Christmas Eve of that year as a gift to the students. In 1899, the building burned nearly to the ground and was quickly rebuilt in 1900. Local families took the girls in during the rebuilding process. One farmer alone took in 25 girls. The photograph above was a gift from Alice and David Lane to the HYS Archives.

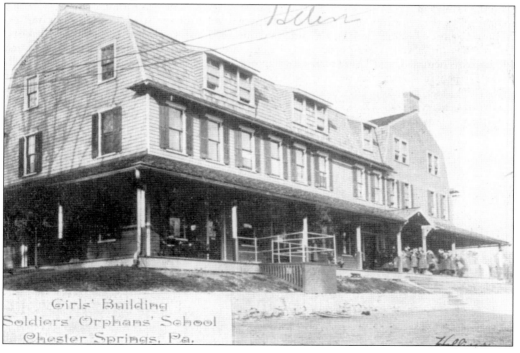

Girls' Building
Soldiers' Orphans' School
Chester Springs, Pa.

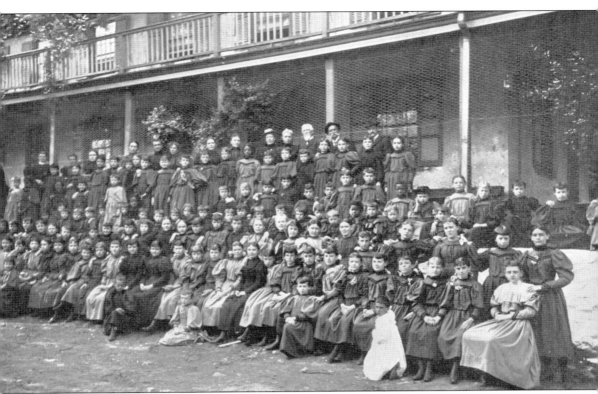

This image, taken around 1897, shows the many girls who attended the school. Everything that the girls wore they made in the school's sewing room. The 1899 annual report gives an indication of the enormity of this task, with the manufacture of "104 blue Henrietta dresses, 56 brown serge, 47 school dresses, 286 gingham dresses, 73 white dresses, 126 red flannel skirts, 119 seer sucker skirts, 28 white skirts, 114 night dresses, 286 gingham aprons, 178 drawers, 248 napkins hemmed, and 134 percale fancy aprons." The girls made the boy's uniforms as well. In the first years of the school's development, according to an 1870 article, the sewing department was in the older section of the Washington Building with three machines and up to 20 girls sewing at a time. Acquiring skills such as sewing was a mainstay of the school's educational purpose and provided young girls with what were considered useful skills for adulthood.

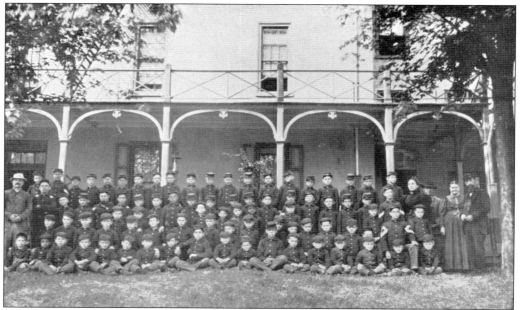

These photographs provide glimpses of the rebuilt Washington Building. Above, male pupils stand in front of the Washington Building porch in 1897. Below, boys stand under the portico that connected the Lincoln Building. The original *c.* 1750 hotel building, which housed male pupils, burned on March 7, 1876. Builders reconstructed the building by connecting it to the "Hall," (foreground) which served as the sewing room and infirmary and was built in the 1820s. The new structure (background) was 37 feet wide and 84 feet long, three stories high, and the mason was Joshua Spare of Phoenixville. According to a *Daily Local News* article from June 27, 1876, "the only portion remaining of the old building is a chimney." The photograph below was donated by Alice and David Lane to the HYS Archives.

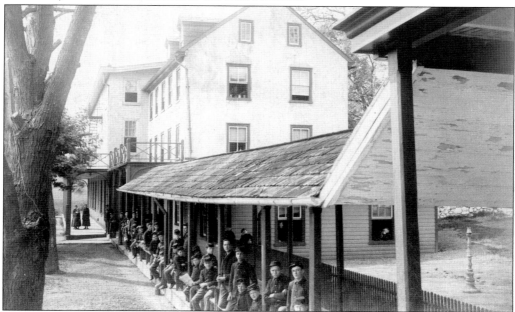

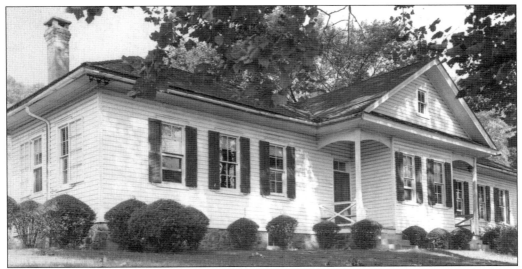

This photograph shows the infirmary building at the orphan school. Built by 1888, the building allowed sick to be removed and cared for away from other students to prevent the spread of disease. In that year, for instance, measles ran rampant through the school, afflicting 37 of the 261 children at one time. School officials avoided a serious epidemic by removing the children from the dormitories so that they could convalesce in the infirmary. (Courtesy of the Vince Spangler Collection, HYS Archives.)

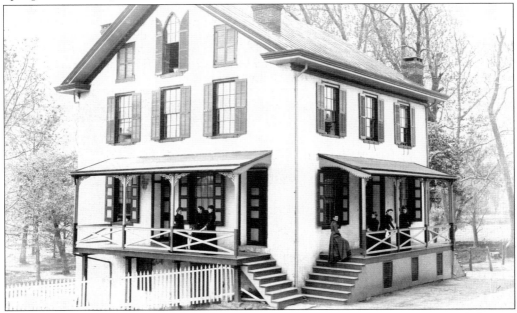

Known as the Main House, this building was home to the school's faculty. Originally known as Our House and called the Rosato House today, the structure once served as the innkeeper's home during the spa era. Although faculty lived here, many staff lived with the students or off site, including teachers, matrons, nurses, male attendants, sewing superintendents, laundresses, stewards, cooks, bakers, farmers, carpenters, plumbers, physicians, and a dining room superintendent. This photograph was a gift to the HYS Archives from Alice and David Lane.

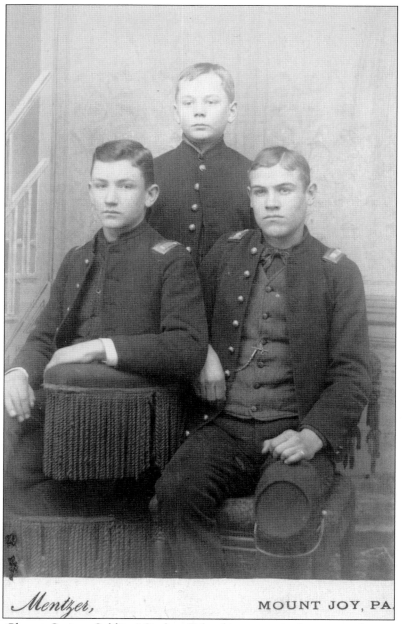

Mentzer, MOUNT JOY, PA.

Boys at the Chester Springs Soldiers' Orphan School were required to wear military uniforms at all times. According to oral tradition, the uniforms were made from surplus fabric left over from Union uniforms from the Civil War. As outlined in an 1873 *Daily Local News* article, "In way of clothing each pupil receives two suits per year—one for summer and one for winter. The summer one comprises two pairs of light material, a black Alpaca coat, pair of shoes and light felt hat. The one for winter wear consists of short blue roundabout, a loose mantle of dark blue cloth, pants of dark blue, two shirts, pair of boots, and a blue cloth cap. This is the allotted apparel to each male pupil." Woven woolen drawers kept them warm through the winter. This photograph was donated by Alice and David Lane to the HYS Archives.

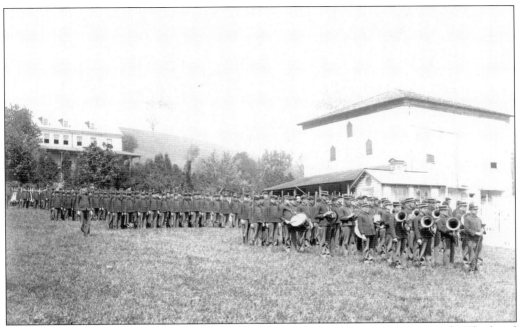

These photographs show the orphan school band performing on the school grounds. The band was a key part of the school's activities and played for military celebrations in the Chester Springs and Phoenixville areas and also at Civil War soldier's graves during Memorial Day. The 1891 image above, donated by Alice and David Lane to the HYS Archives, shows the barn in the background, which served as a stable for the school's horses. Today it is an art studio. The adjoining fields were where the girls played. The 1899 image below shows the band between the Lincoln and Washington Buildings.

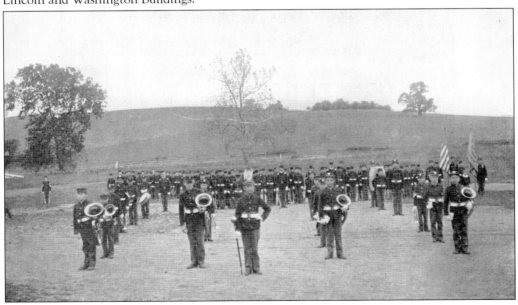

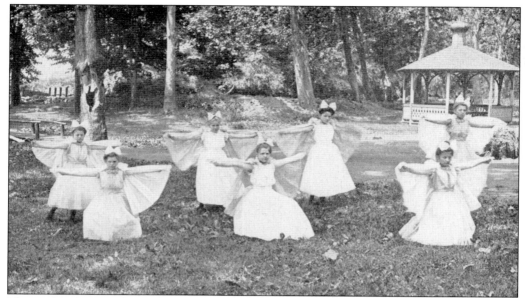

These 1902 images show the girls of the orphan school in the middle of drills, most likely during the annual exams. The girls performed the Butterfly Drill (above) in front of the gazebo in the parade grounds. In the Japanese Drill (below), the girls wore kimonos, held parasols, and displayed corresponding hairstyles in a performance for the crowd. In fact, sometimes performances by boys and girls took on an almost competitive flavor. In 1904, the *Daily Local News* noted that "the girls, especially, did finely, and while the boys did well, the girls surpassed them in drill, calisthenics and other exercises."

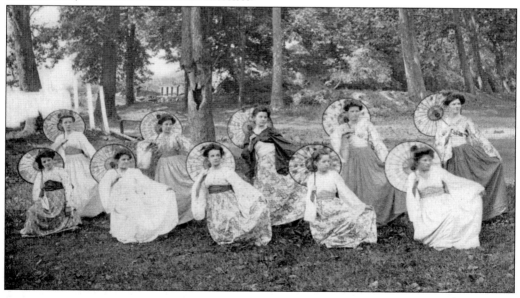

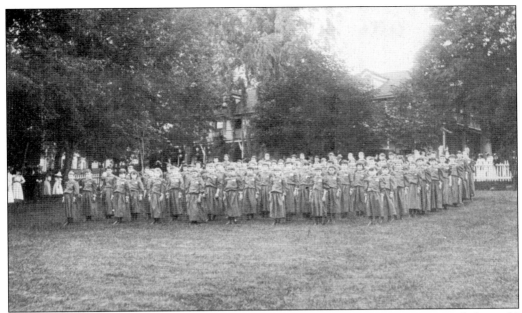

Physical education and calisthenics, in particular, were a very important part of the girls' educational experience. The girls performed gymnastics and calisthenics at every commencement day examination in front of hundreds of spectators. In 1894, the girls donned their gym uniforms (above) for a performance in the girls play area in front of the Lincoln Building. The girls performed the pole drill (below) in 1903 on the parade grounds in front of the laundry facility. The Pennsylvania Academy of the Fine Arts converted the laundry building in the background into a pool house in 1921.

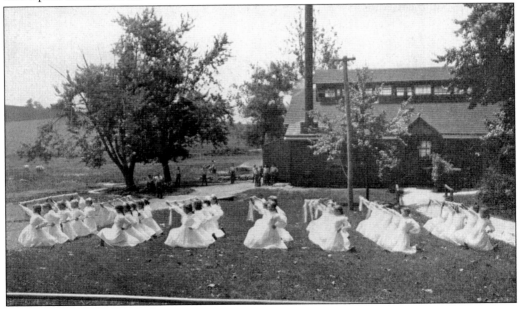

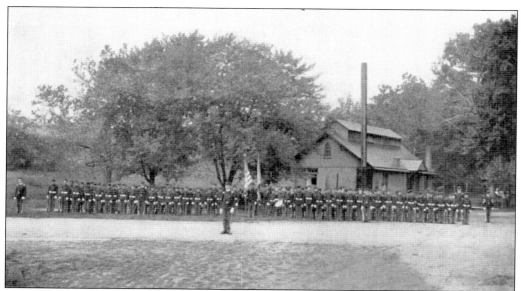

Military exercises were a regular part of the students' education. The students put on programs for special occasions and drills were an important feature of their annual exams. A faculty member was appointed as a special military instructor for such exercises. The 1899 photograph entitled *Boys Battalion Dress Parade* (above) shows the laundry building that was built on the original site of early springhouses. The *Daily Local News* of September 25, 1891, noted the building's construction: "The mechanics have commenced the erection of a brick building, 80 by 40 feet, at Chester Springs, which is to be used as a steam laundry at the Soldiers' Orphan School." The 1902 photograph below depicts a tableaux entitled the Surprised Outpost.

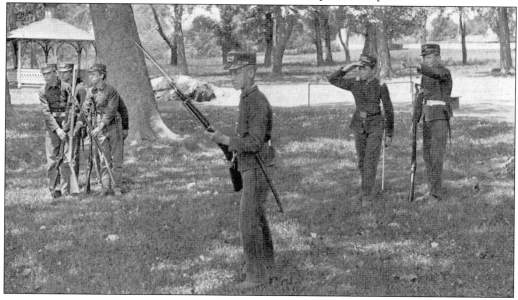

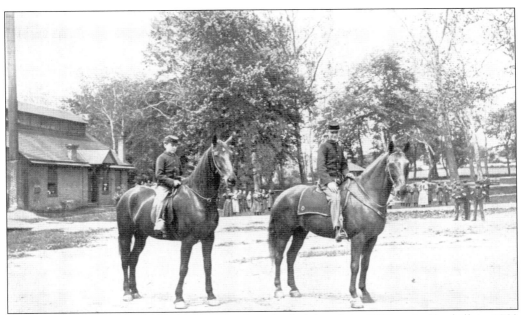

These two photographs show students on horseback (above) in 1897 and rifle drill in 1902 (below). Weaponry was a regular part of the military drills performed by the boys. An 1895 *Philadelphia Inquirer* story noted patriotically that "Cannon were booming and on the lawn in front of the Soldiers' Orphan School a battalion of boys were drawn up in martial array, clothed in new uniforms, with burnished rifles and glistening swords, and 'Old Glory' waving to the breeze." Around that time, the school had 325 students enrolled.

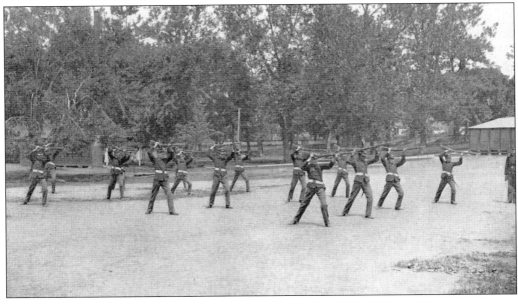

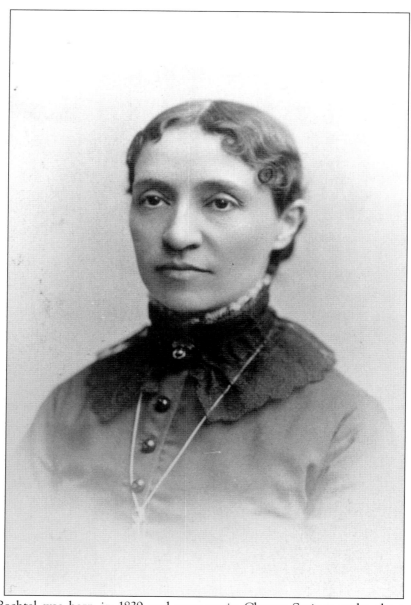

Eleanor Bechtel was born in 1839 and grew up in Chester Springs under the tutelage of Graceanna, Elizabeth, and Mariann Lewis, sister abolitionists who maintained a stop on the Underground Railroad. Eleanor married David Moore in 1859 and he later served in the Civil War. After the war, the family traveled to Helena, Arkansas, where they worked during the Reconstruction planting cotton and hiring freed slaves. Moore and a son died in an epidemic of Asiatic cholera, and Eleanor returned to Chester County with daughter Ada and baby son Ziba. They lived with the Lewis sisters. She started to work at the orphan school as a matron and became principal in 1873. Under her direction, the school thrived, as Eleanor pushed children to focus studies on areas such as music and literature instead of exclusively on trades. Graceanna Lewis wrote of her in the *Women's Journal*, saying Eleanor was "a just tribute to womanhood of the highest order." She was the only female principal in the state school system.

Matthew Simpson McCullough was president of the board of trustees of the stock company that managed the Yellow Springs property. Eleanor Bechtel Moore and Matthew McCullough were married August 31, 1882, in Philadelphia. Eleanor resigned her position as school principal and the couple moved to Philadelphia. In 1883, McCullough purchased 250 acres of shore property on the lower end of Absecon Island (now Longport), New Jersey. McCullough died in 1906 and Eleanor died on January 31, 1926.

Eleanor Bechtel Moore's daughter Ada traveled with her from Arkansas back to Chester Springs following the death of David Moore and their son. In 1874, newspapers list Ada as part of the faculty at the school. She later married and moved to Kennett Square. (Photograph by A. K. P. Trask; Courtesy of the Chester County Historical Society.)

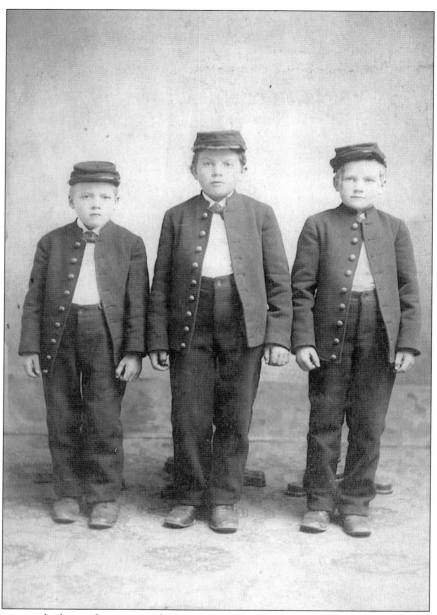

This photograph shows three sons of Thomas Cresswell of Girardville. Thomas Cresswell was a member of Company B, 14th Regiment Pennsylvania Volunteers during the Civil War and reenlisted in Company L of the 5th U.S. Army Regiment. He was discharged on December 19, 1864, soon married, and fathered 10 children. Upon his death, three of his children attended the Chester Springs Soldiers' Orphan School. From left to right, they are Walter Harris Cresswell, Abraham Lincoln Cresswell, and George Washington Cresswell. Family history holds that all three added their middle names later in life, with Abraham and George perhaps adding "Lincoln" and "Washington" to pay tribute to the history of Yellow Springs. Newspaper records indicate that George graduated in 1893. This photograph was donated to the HYS Archives by Robert Creswell (the second "s" was later dropped), son of George Washington Cresswell.

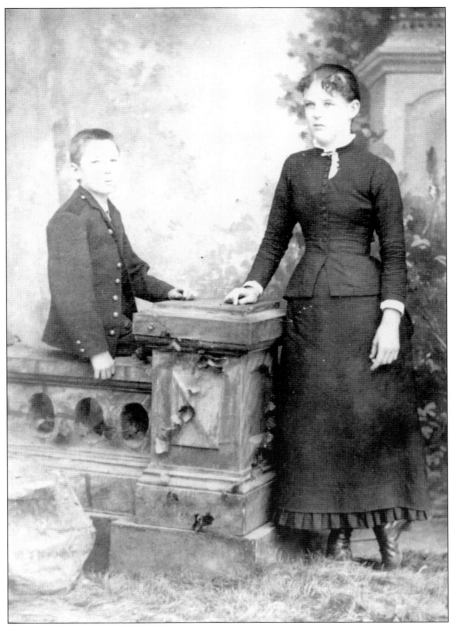

This image, a gift from May Pitman Piccioni to the HYS Archives, shows students Robert Asher Pitman (left) and Anna May Pitman (right). The father of these siblings was congressional Medal of Honor winner, George Justice Pitman. George served during the Civil War in Company C of the First New York Cavalry. After the war, he died at the young age of 48 in a building accident. Due to his veteran status, his children were entitled to attend the Chester Springs Soldiers' Orphan School. The *Daily Local News* noted, "May Pitman's" departure from the school at the age of 17 in 1888. She acquired deft drawing skills at the school and sold illustrations later in life. Robert, born in 1875, graduated from the school in 1891 and went on to attend the Williamson Trade School in Media.

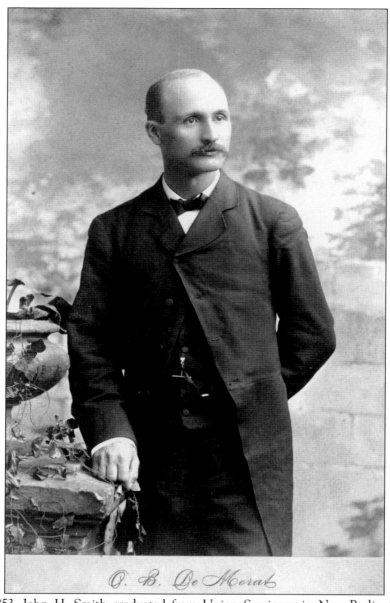

O. B. De Morat

Born in 1853, John H. Smith graduated from Union Seminary in New Berlin in 1873. A professional educator, he taught from 1884 to 1890 at the soldiers' orphan schools in Mercer and Mount Joy. In 1890, he moved to Chester Springs to manage the Chester Springs Soldiers' Orphan School. At that time, the school had 274 students, one principal, and six teachers. During the school's operation, managers like Smith oversaw the entire operation of the school with a particular focus on the actual property. According to the 1893 *Cyclopedia of Biographies, of Chester County, PA*, by Samuel T. Wiley, "For the health and comfort of these children, Professor Smith has made the same careful provision that he has for their education and moral instruction. The Chester Springs home and grounds are pleasantly and healthfully situated, proper exercise is provided for, and the school rooms are carefully fitted up for convenience, comfort and health." This photograph was donated by Alice and David Lane to the HYS Archives.

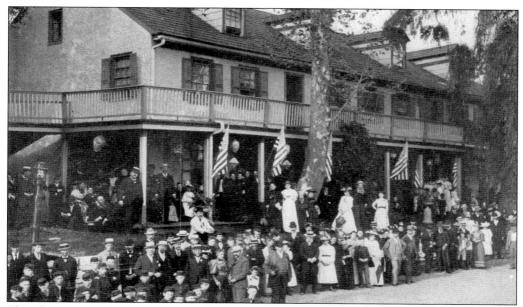

This photograph shows Examination Day in 1896. Examination Day for the school was an event of crucial importance not just for the school, but also for the entire region. Everyone from local farmers to state dignitaries visited to view the progress of the children as they put on plays, recited poems, performed military drills, and took oral examinations on their studies. Subjects included geometry, algebra, botany, natural philosophy, and physiology. Students proudly displayed samples of penmanship, letter writing, bookkeeping, and drawing. School system officials even toured the rooms, checking for order, cleanliness, and care of clothing.

This postcard view looks east down the road known today as Art School Road. Note the early electrical wires. Newspaper clippings indicate that the buildings had electricity by 1900 and that after the fire at the Lincoln Building, oil lamps were discontinued and electricity was installed in that building.

This postcard image shows the west end of the laundry facility, which later became the pool house during the Pennsylvania Academy of the Fine Arts era. Students used the rowboat on the nearby pond that doubled as the village's ice supply in the winter. (Courtesy of David J. Monteith.)

This image shows the west end of the Washington Building with the western addition. This western section of the building was most likely a separate structure, with an open walkway between it and the main portion of the building. At a later date, that structure was permanently connected to the Washington Building. (Courtesy of David J. Monteith.)

In this postcard, the Lincoln Building looms on the right with the Main House on the left. The building in the background later became the exhibition building for the Pennsylvania Academy of the Fine Arts. Its use during the orphan school era is unclear. (Courtesy of David J. Monteith.)

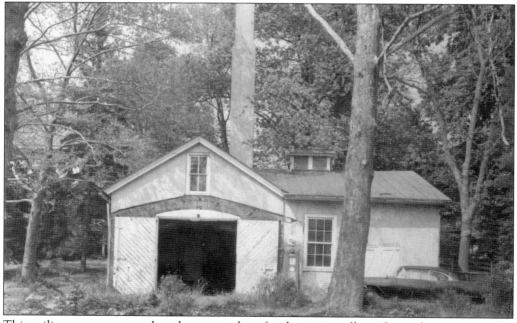

This utility structure served as the steam plant for the entire village. Steam heat came to the village in the fall of 1890, replacing earlier stove heat. By May 1891, the *Daily Local News* boasted that "steam heating, hot and cold water bath also form additional comforts under the new order of things" at the school. (Courtesy of the Vince Spangler Collection, HYS Archives.)

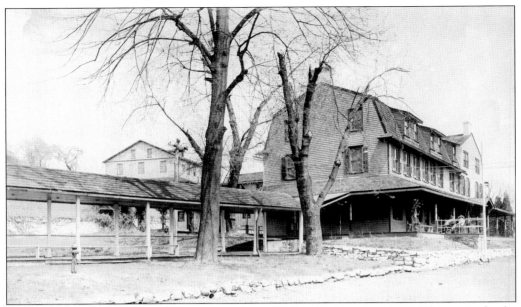

The flagpole on the right has been in the village of Yellow Springs since 1892. The original pole, erected in 1873 behind the Lincoln Building, was intended to be the country's longest with the largest flag, standing 210 feet high and 18 feet in diameter at the base. It had to be shortened to 166 feet high and 18 inches in diameter. (Courtesy of the Chester County Historical Society, West Chester, PA.)

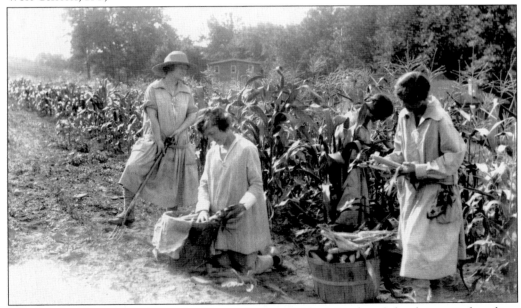

The farm had been operating at the Chester Springs Soldier's Orphan School since its founding. This photograph, taken around 1912, shows women picking corn in an area that today is a paved parking lot. Actual farmers managed the farm, although students and staff also worked the fields. The produce formed the basis for many of the school's meals, and farming offered practical work experience for the students.

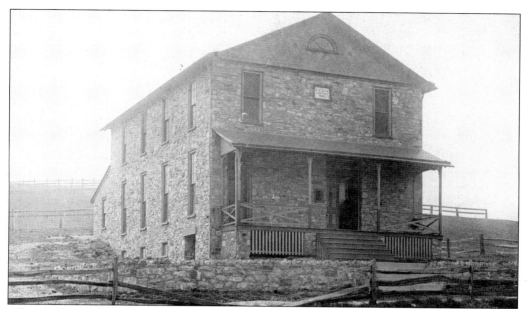

After the hospital fire of 1902, the children used this nearby building belonging to the Patriotic Order Sons of America. At that point, the Patriotic Order Sons of America's building was brand new, having been built in 1901 and completed in 1902. The Patriotic Order Sons of America was and still is a patriotic social organization. The Chester Springs Washington Camp No. 275 was founded in 1887 and met in the Revolutionary War hospital before building its own hall.

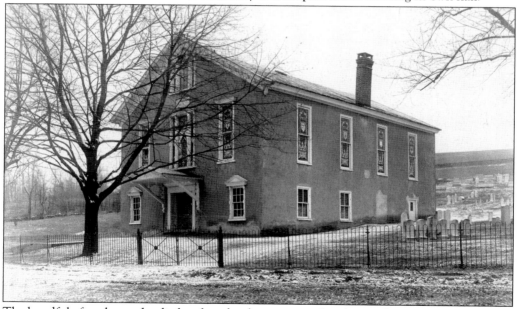

The handful of students who died at the school were interred at the nearby West Vincent Baptist Church. There a special monument to those children that still stands with 14 names listed. Students observed Memorial Day by visiting the graveyard and other cemeteries in that vicinity and decorating the graves of the veterans and orphan children buried there. (Courtesy of the Chester County Historical Society, West Chester, PA.)

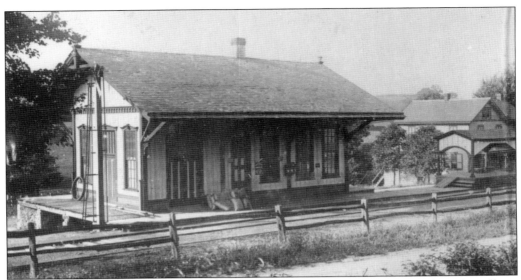

These two images show some of the features of the area immediately surrounding the village. The Chester Springs train station (above) was on the Pickering Valley Railroad that opened in 1871 as a branch of the Philadelphia and Reading Railroad. The Chester Springs station closed around 1933 and passenger service stopped five years later. The train line delivered coal to the school and the school paid part of the stationmaster's salary. Mothers used it to visit their children, viewers traveled by the line to the school on commencement day, and of course, students boarded it to go home during the six-week-long summer vacation before returning in the fall. The 1897 photograph of the local blacksmith shop (below) was located at the intersection of Lionville and Kimberton Road (Route 113) and Pikeland Road. The building no longer exists, and the site is currently occupied by Hallman's General Store. (Below, courtesy of Harold Hallman Jr.)

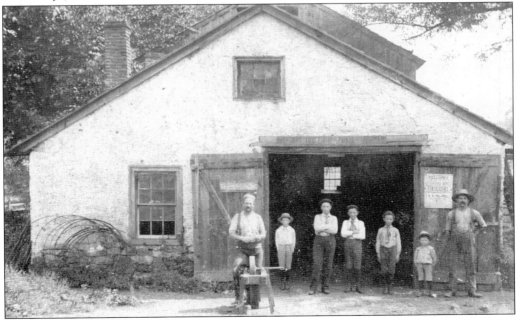

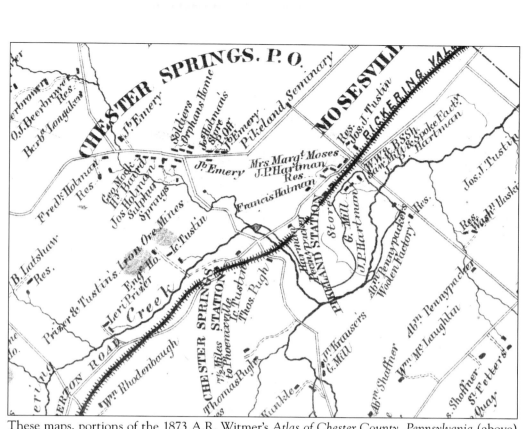

These maps, portions of the 1873 A.R. Witmer's *Atlas of Chester County, Pennsylvania* (above) and the 1883 *Breou's Official Series of Farm Maps, Chester County, Pennsylvania*, give a general impression of the variety of businesses, institutions, and residents all packed within the small area of Chester Springs in the late 19th century. Within a mile of the orphan school were two train stations, two stores, the post office, the nearby Pikeland Seminary, and dozens of residences. Iron mines supplied iron for nearby Phoenix Iron Works. (Above, courtesy of Rob Lukens.)

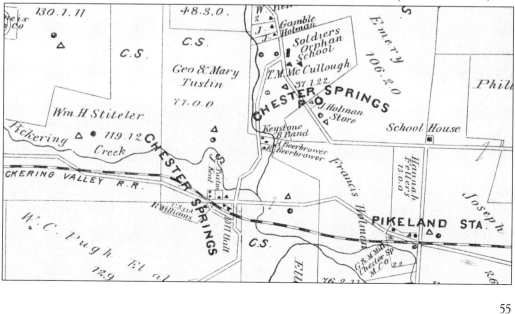

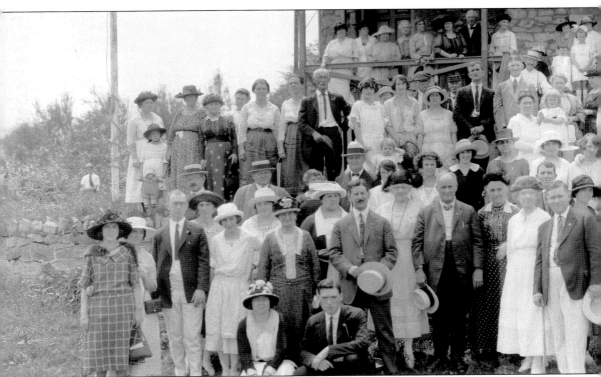

The *Daily Local News* from August 7, 1922, called this annual reunion of the "Sixteeners Association of the Chester Springs Soldiers' Orphan School" the "happiest on record." The alumni "found delight in roaming through the buildings, now the country home of the Pennsylvania Academy of the Fine Arts, and recalling the old jokes and the old stories." Eleanor Moore McCullough (first row standing, near the center wearing a white dress with a darker hat), then 84 and sharp as a tack, was the feature of the day at the Patriotic Order Sons of America

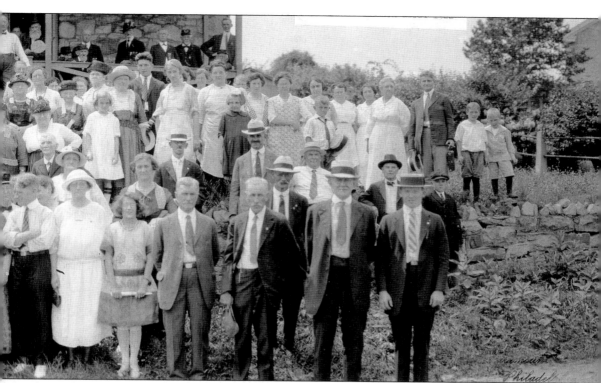

hall in the village. She "spoke in a wonderful way to her former children." And "though in her 84th year, she used no manuscript and never hesitated, the hearers easily fancying themselves as forty to fifty years ago in the old dining room, listening to her clear, well modulated voice. This was freely pronounced the gem of the day." This photograph was donated to the HYS Archives by James O. Moore in memory of his great-grandmother Eleanor Moore McCullough.

These two photographs show Alumni Day at the school around 1900. The pair above are Rev. Milton E. McLinn (right) and Thomas S. James (left), who both sit in front of the Lincoln building. Historical records indicate that McLinn served as principal teacher in 1882, second only to R. S. MacNamee, principal at that time. In that year, there were seven instructors and 190 students. As the overall view of the Lincoln Building shows (below), Alumni Day was a big deal. Such an occasion warranted much in the way of decoration and pomp. (Courtesy of the Chester County Historical Society, West Chester, PA.)

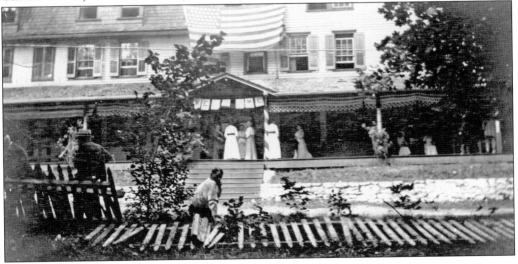

Three

PENNSYLVANIA ACADEMY OF THE FINE ARTS COUNTRY SCHOOL

Over the hills and up the village streets; by the streams and under the trees,
they invade the charm of Chester County farmlands with palette and brush
and enthusiasm. They are the artists of Chester Springs

—*Evening Public Ledger*, Philadelphia, July 6, 1935

The historic village of Yellow Springs located in Chester Springs has always been noted for its beautiful landscape. It was this beauty and serenity that prompted John Frederick Lewis, president of the Pennsylvania Academy of the Fine Arts in 1916, to purchase a 37-acre property that he believed was well adapted for a summer school. The academy thought it fitting that the oldest school of fine arts in the country should be at this historic spot. In the summer of 1917, the academy came to Chester Springs.

By 1917, as the American art scene felt the impact of French Impressionism, the Pennsylvania Academy of the Fine Arts recognized the need for a summer school of landscape painting. In contrast to urban art education facilities, the academy's country school provided for en plein air (in the open air) painting. As described by an early catalogue, "The chief objective of the Academy in establishing a summer school in the country is to supplement the work done during the winter at its school in Philadelphia, by instruction in painting in the Open Air."

In addition, special gardens were established by an English landscape gardener with help from students. The pond, pool, and tennis courts provided recreation in the summer, while the snow-covered hillside offered skiing and tobogganing in the winter. There was fine music, plays, lectures, and, of course, the art that allowed artists to pursue their work in a creative environment. Artists, themselves, described the experience as "paradise."

In 1951, the academy announced "that the Country School at Chester Springs will not be open this year." Life had changed after World War II and so had art. Student and teacher Roswell Weidner said that the art at Chester Springs was "the last gasp of the realistic tradition." After the war and into the 1950s, abstract and non-representational painting was important.

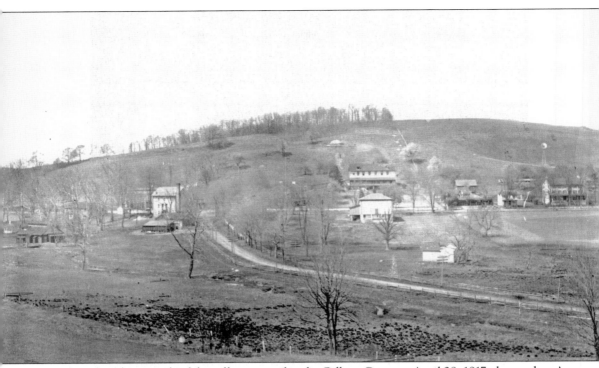

When this photograph of the village was taken by Gilbert Cope on April 28, 1917, the academy's country school had just opened for its second summer season. The school's opening was a realization of academy president John Frederick Lewis's dream of a landscape-oriented campus. Lewis knew of the site because his parents had honeymooned there and he owned a nearby dairy farm. The year of the school's opening, 90 students enrolled between March and October. That number rose to 168 attendees the following year. Rates for board and tuition were $10.50 per week. Lewis handpicked D. Roy Miller, a recent graduate of the academy, as the manager of the country school. Students lived in sharp contrast to their urban counterparts, relying on milk, eggs, and fresh vegetables from farmers in the area for their meals. (Courtesy of the Chester County Historical Society, West Chester, PA.)

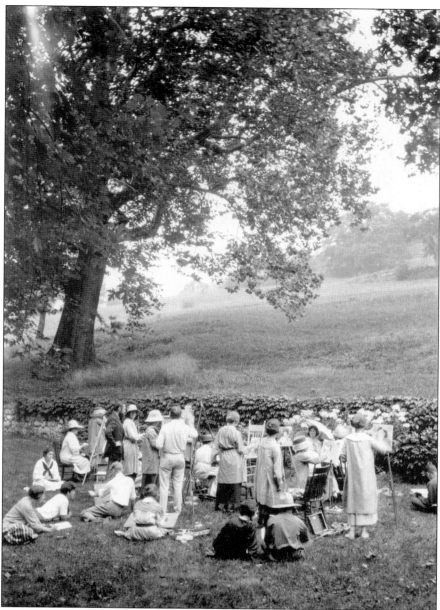

Arthur B. Carles, the bearded instructor shown here, was born in Philadelphia in 1882. Beginning in 1900, he studied at the Pennsylvania Academy of the Fine Arts under the tutelage of noted artists Thomas Anshutz and William Merritt Chase. Carles got his start at Alfred Stieglitz's Gallery 291 in New York when Steiglitz gave him a one-man show in 1912. The following year, Carles's work was highlighted in the famous 1913 Armory Show in New York City. Carles returned to the academy as an instructor from 1917 to 1925 but was dismissed from the academy in 1925 due to "uninhibited behavior and flaunting of convention," as stated by Carles biographer Barbara Wolanin. After continuing his career as a private teacher, Carles's life was plagued by alcoholism. He had a bad fall that partially paralyzed him in 1941, confining him to a wheelchair, and he died in 1952.

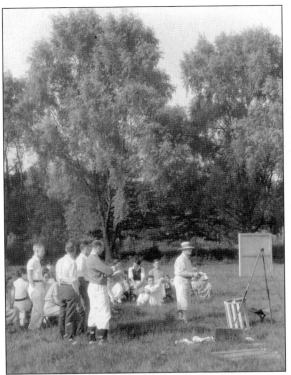

The image to the left shows Daniel Garber teaching classes in the meadow with 1930s manager Joseph Frazer standing in the foreground. In the image below, Garber is in a classroom, possibly the studio in the old Revolutionary War hospital. Garber, who was born in Indiana in 1880, attended the Pennsylvania Academy of the Fine Arts from 1899 to 1905, as well as the Darby School of Art headed by Hugh Breckinridge and Thomas Anshutz. After a trip abroad, he and his wife settled near New Hope, Bucks County. Garber taught at the Pennsylvania Academy of the Fine Arts for 41 years, starting in 1909. During many of those years, he taught a wide array of classes at the country school. For instance, the 1929 catalog list of his summer classes includes landscapes, outdoor portraits, still lifes, etching, and drawing from a costumed model.

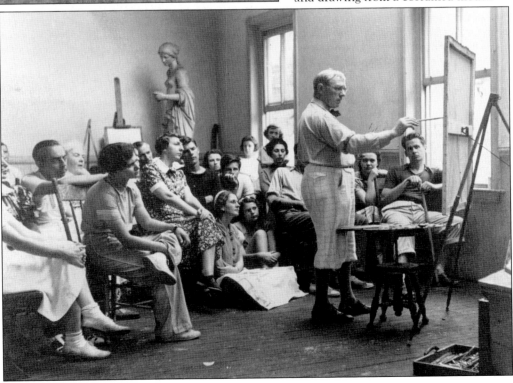

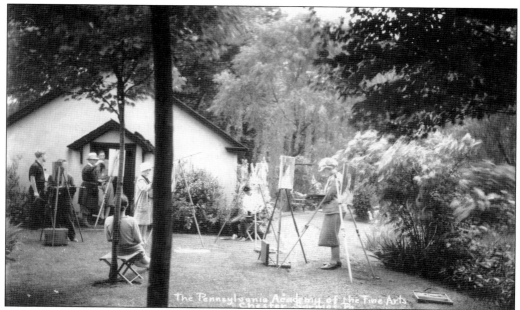

The Pennsylvania Academy of the Fine Arts

These images show Garber in front of the Crystal Diamond Springhouse (above) and behind the Washington Building (below) seated with his signature brimmed hat. Like many of his contemporaries, Garber's French-influenced impressionistic landscapes were a hallmark of the early country school works. Although he painted many scenes of the Chester Springs area, he was most famous for his luminous paintings of the landscapes near his home in Bucks County. Indeed Garber's favorite command to his students was "See the light!" Today those paintings are in the collections of some of the country's most prestigious museums, including the Corcoran Museum of Art, Metropolitan Museum of Art, Art Institute of Chicago, and, of course, the Pennsylvania Academy of the Fine Arts.

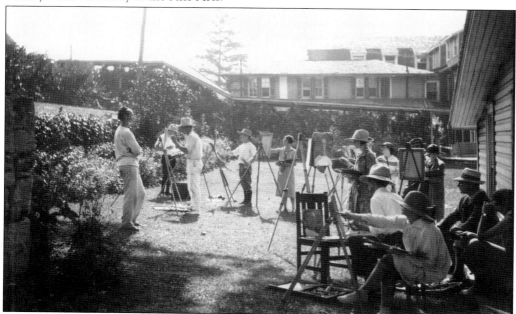

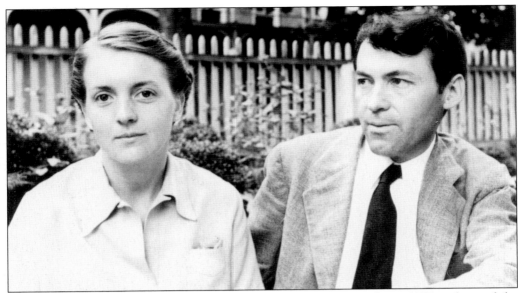

This photograph shows Francis Speight and Sarah Blakeslee Speight in 1937 in front of the Washington Building. Sarah was born in Evanston, Illinois, in 1912. She met Francis when she attended the academy's country school as a student and he was her instructor. Sarah was 16 years Francis's junior, but the two married in 1936 and lived in Bucks County until 1961 when they moved to Greenville, North Carolina. Sarah painted portraits, landscapes, and still lifes and worked in both oils and watercolors. Like her husband, she received the venerated North Carolina Medal of Achievement in the Fine Arts. She passed away early in 2005.

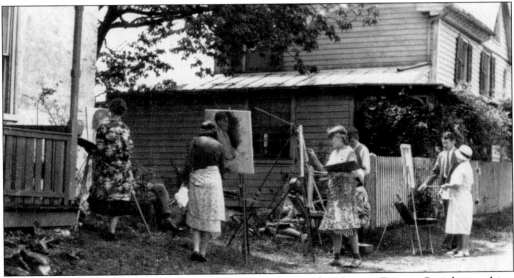

This image, a gift to HYS Archives from Elisabeth Speight, depicts Francis Speight teaching a painting class in front of the Holman General Store in the village. Speight, a native North Carolinian, studied at the academy from 1920 to 1925. He moved on to teach at the academy from 1925 to 1961 while specializing in contemporary realist landscape painting. He married one of his students at the country school, Sarah Jane Blakeslee, in 1936. After moving back to North Carolina, Speight received the North Carolina Medal of Achievement in the Fine Arts in 1964.

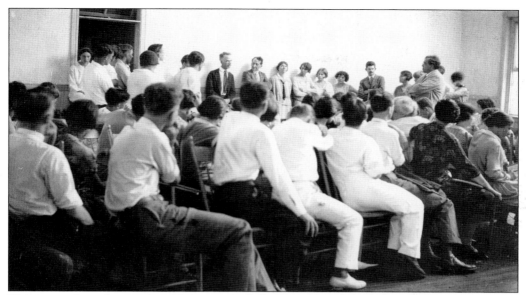

This image shows famous American artist and illustrator N. C. Wyeth (standing, right) lecturing in what was most likely the old Revolutionary War hospital. In 1926, Wyeth lectured on decoration at the country school. Instructor and school employee Mildred Miller took students on trips to Wyeth's studio in Chadds Ford, and Wyeth also helped by critiquing students' works. When Wyeth refused payment, Pres. John Frederick Lewis worked out a system where he paid Wyeth, Wyeth purchased student works, then he donated the works to the school.

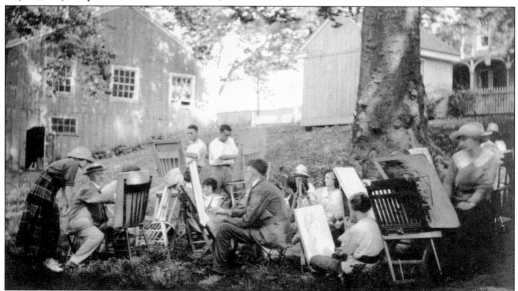

Instructor Henry McCarter (seated on the left) was born in 1886 in Philadelphia. McCarter studied with leading Parisian artists and locally with Thomas Eakins. Here he teaches a portrait class next to the Main House in 1917 or 1918. The 1929 class catalog lists McCarter as an instructor of decorative design and color, and noted that he encouraged students to express forcefully their own impressions and conceptions. McCarter also illustrated for *Scribner's*, *Century*, *Harper's*, and *Collier's* magazines.

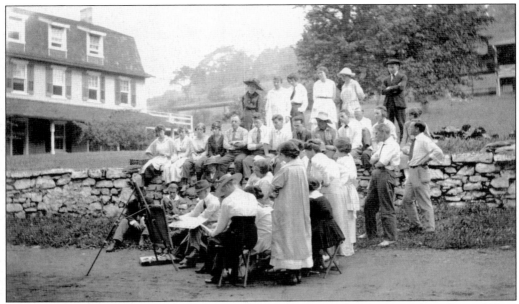

Teacher Hugh Henry Breckinridge (seated) attended the academy as a student from 1887 to 1892. He began teaching at the academy in 1894, and in 1900, he and fellow artist Thomas Anshutz created the Darby School of Painting in Darby outside of Philadelphia. Shortly after this photograph was taken around 1918, Breckinridge became the director of the fine arts department at the Maryland Institute in Baltimore.

Here Mildred Miller stands next to her dog behind the sculpture studio barn. Roy and Mildred Miller were students together at the academy and managed the country school for nearly two decades. The two married in June 1916 and moved to the village shortly thereafter. Mildred managed the buildings' furnishings and amenities and taught painting. In the early 1930s, the relationship between the city school and country school deteriorated, and in 1934, the Millers were dismissed. They then created their own painting school nearby on Yellow Springs Road.

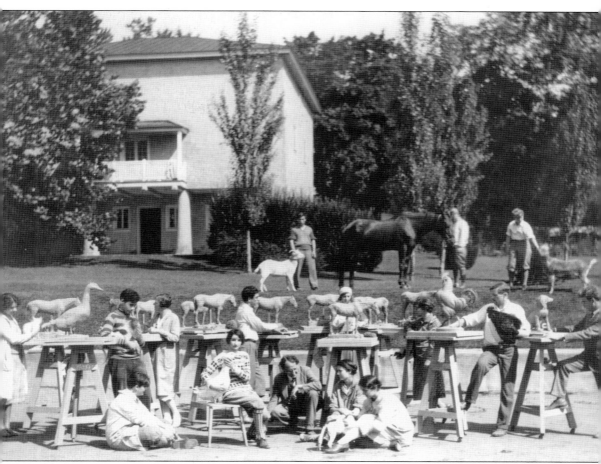

This 1921 photograph shows Albert Laessle (center, kneeling) teaching a sculpture class with live animal models behind the newly opened studio building. Born in 1877, Laessle's earliest work in animal sculpture was so realistic that his fellow students wondered if he had actually cast real-life animals to create them. In Philadelphia, his most famous and visible work is the two-foot high goat, *Billy*, in the city's Rittenhouse Square.

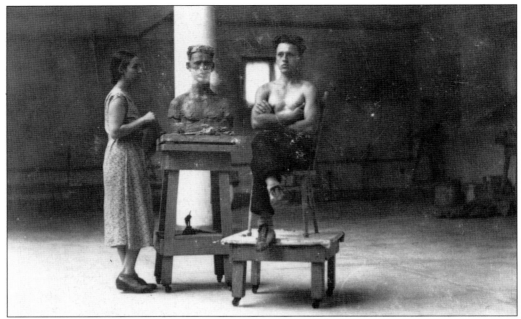

As this image shows, artists sometimes served as models. This image shows Margaret Smoot sculpting fellow artist Roswell Weidner inside the large studio barn today known as the Cultural Center. Records indicate that Smoot, born 1907, later married country school instructor and sculptor Albert Laessle.

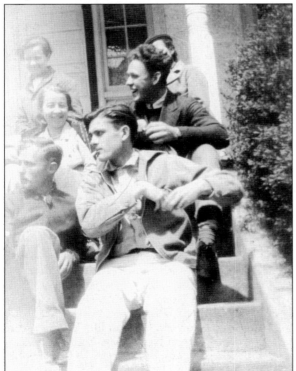

Here Roswell Weidner (second row, right) and other students sit on the front steps of the Lincoln Building. Born in Reading in 1911, Weidner received a scholarship from his high school to attend the country school. He completed his studies at the academy's city school in Philadelphia and the Barnes Foundation. For 66 years, he remained associated with the academy as student and teacher until his retirement in 1996.

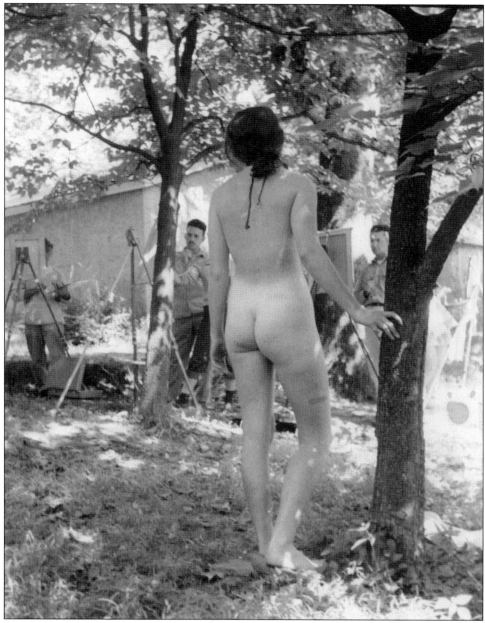

In this photograph, Weidner paints a nude in front of the crystal diamond springhouse around 1939 or 1940 or shortly after World War II. According to Weidner, during the 1930s, the main emphasis of the school was not on landscape painting. Rather, equal emphasis was given to all subject matter and realism was the preferred style. During World War II, Weidner worked in New Jersey as a pipe fitter and expediter. Afterwards, he purchased a farm in the countryside outside of Philadelphia and resumed his teaching at the academy. Later in life, Weidner spent many years painting landscapes of the Pine Barrens of southern New Jersey. Among the many distinguished awards he received was the Liberty Bell Award given by the mayor of Philadelphia. This photograph was donated by Marilyn Weidner to the HYS Archives.

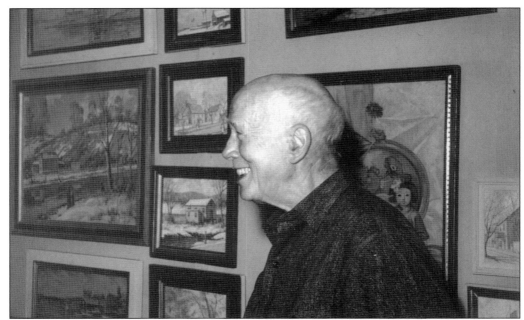

This pair of images shows Albert Van Nesse Greene in 1964 (above) and his Chester Springs home (below). Born in Jamaica, New York, in 1887, Greene both attended and taught at the academy country school and continued to live just outside of Yellow Springs village in this modest home until his death in 1971. His studio still stands today. As recalled by local resident Roberta Rometsch, even into his older years, Greene "painted every day from six to nine a.m. because he thought the light was best then." Every day at 9:20 a.m. and 4:20 p.m. he strolled down the road to visit Hallman's General Store at Route 113 and Pikeland Road. Both photographs were gifts to the HYS Archives; the above photograph was donated by Roberta Rometsch, and the photograph below was donated by Roland Maynard.

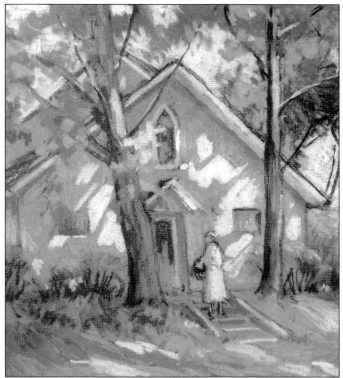

Greene was well known for his impressionistic scenes of local landscapes. He painted this rendering of the country school's pool house (left) in *Yellow Springs Village III.* His artistic creativity even graced the Christmas cards he sent out, as in the one printed below. Greene served in World War I and was injured on the last day of the war, making the act of painting difficult for him. Ever the generous man, when he died, he left his paintings to the federal government in gratitude for the pension he received his whole life as a result of his injury. The Christmas card below was donated to the HYS Archives from Roland Maynard.

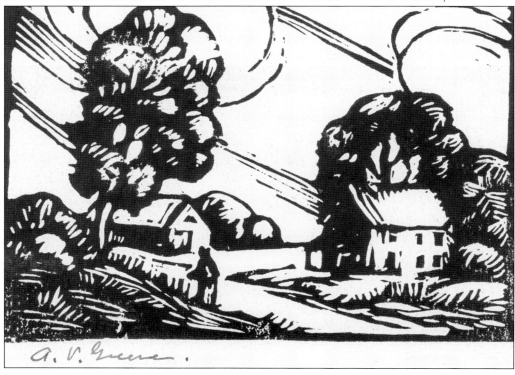

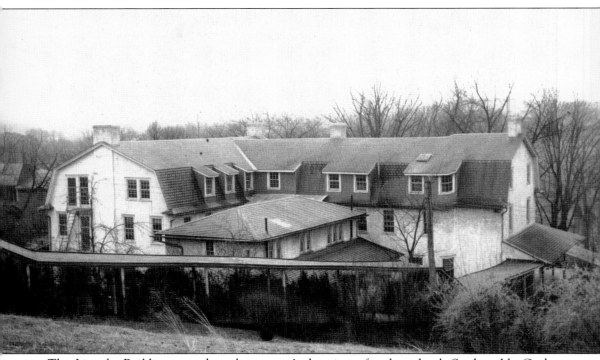

The Lincoln Building served as the women's dormitory for the school. Student Ida Geyler Tollenger, who attended the school in the 1930s, was thrilled by the accommodations. She noted in letters that "we have hot and cold water all the time and you can take a bath anytime you want. The tubs are always cleaned about 2:30 in the afternoon. So, I always try to be one of the first to take a bath." She also remarked that "the school supplies a clean hand towel and soap every day and every week a clean sheet and pillow case." Tollenger also raved about food that she and other students enjoyed as part of their room and board. "I had the largest ear of corn I have ever seen, potato salad, homemade biscuits, coffee, ham and cheese, ice cream with fresh peaches and chocolate cake," she wrote home in exaltation.

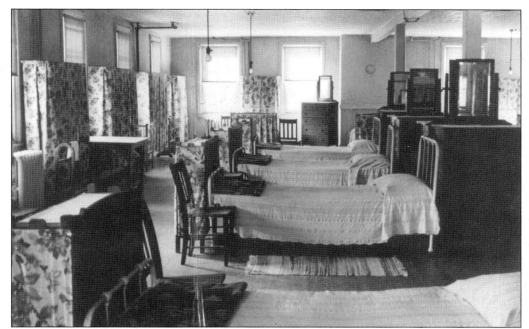

These photographs show the interior of the women's dormitory in the Lincoln Building. Above, although the women had their own furniture, there was little privacy in the second floor living area. The below image shows the first floor foyer, which led to the library and lounge areas. These images may look serene and homey, but students' social lives were anything but staid, with parties, dancing, outings, and indoor and outdoor activities of all kinds constantly available. As recollected by former student Hugh Bodine, "The boys one night visited the girls dormitory and poured beer over the girls' heads while they were in bed."

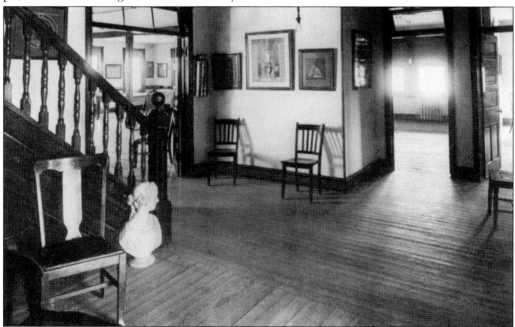

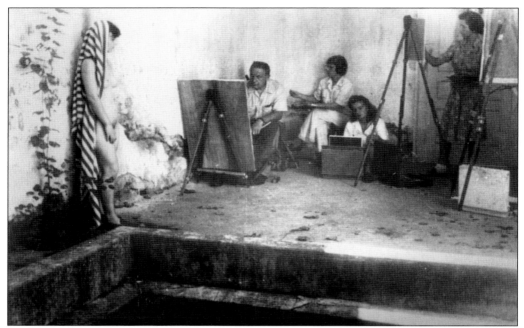

At the country school, Yellow Springs' many historic structures meshed seamlessly with the natural beauty to provide the perfect venue for painting. These images show painting classes held inside the Jenny Lind Springhouse. The above photograph was taken around 1940. In addition to the artistic inspiration provided by the three springhouses on the property, they served practical purposes as well. The Crystal Diamond Spring provided the entire village with its water supply. Additionally, during prohibition, former student and instructor Roswell Weidner recalls, the Crystal Diamond spring was the perfect place to keep beer cool.

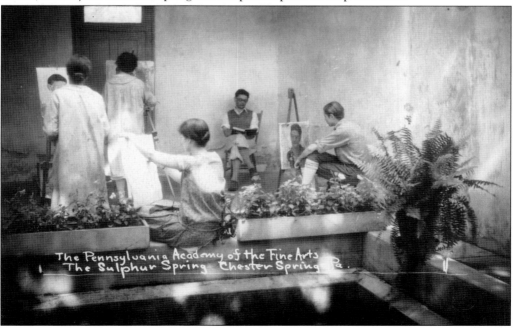

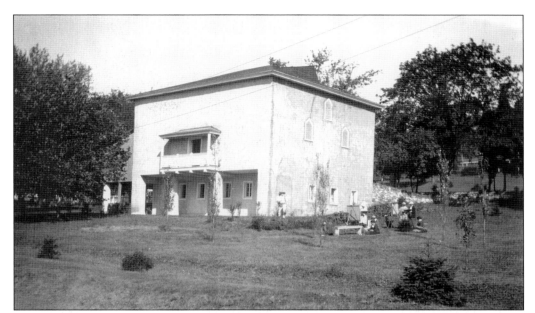

This photograph shows the rear of the barn across from the Lincoln Building that served as a stable during the orphan school era. In 1921, the academy renovated the structure. As explained by the 1922 annual report, "During the past season an old barn has been transformed into a splendid studio for the teaching of sculpture."

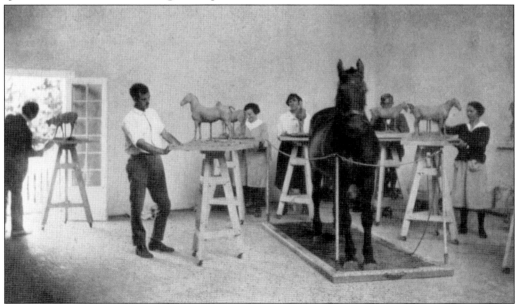

This 1920s photograph was taken inside of the sculpture studio across from the Lincoln Building. The school's sculpture instructors emphasized the use of live animal models, and the large and rough studio facilities at the country school afforded them the opportunity to use horses and other large animals indoors. The students had to purchase their clay, plaster, and plasteline at the school store at Chester Springs and provide their own armatures, stands, and buckets for clay.

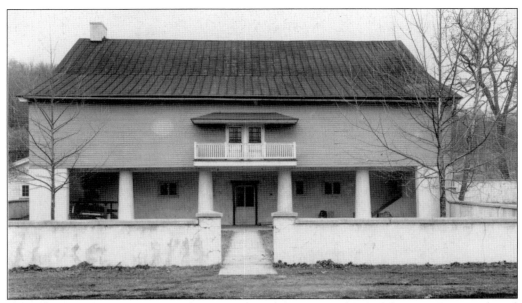

When John Frederick Lewis, president of the Pennsylvania Academy of the Fine Arts, purchased the village property in 1916, it was only 37 acres at the time. In 1928, due to the continued success of the country school, the academy purchased the adjacent 100-acre chicken and grain farm. The expanded property included the large barn on the east end of the village seen here, which the academy converted into a sculpture studio. According to noted sculptor Angelo Frudakis who attended the school in the 1940s, Chester Springs was a "Shangri-la" and "the Sculpture Barn was like a cathedral, with great north light—the three dimensional lighting that you needed." Frudakis is famous for his 1980 work *The Signer*, which is located next to Independence Hall at Fifth and Chestnut Streets in Philadelphia. (Above, courtesy of the Vince Spangler Collection, HYS Archives.)

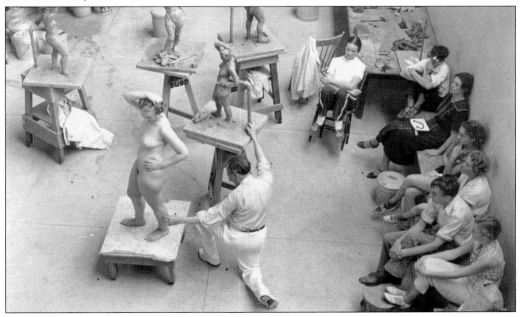

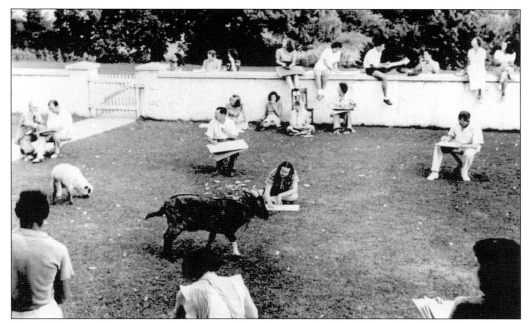

This 1935 image shows renowned artist and academy teacher Roy Nuse off to the left kneeling in the courtyard of the sculpture barn. Nuse, a member of the Bucks County group of impressionist artists, attended the academy (and its country school) from 1915 to 1918 and learned under Daniel Garber and others. He later taught at the academy from 1925 to 1954.

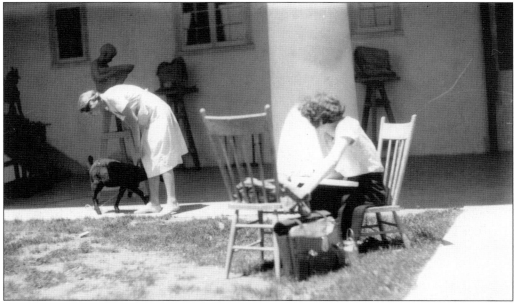

The sculpture studio's front courtyard acted as a corral to keep animals while they modeled for students. Two goats, Nip and Tuck, were regular mascots around the country school. According to former student and teacher Roswell Weidner, students sometimes caught wild birds and animals as their sculpting subjects. For the more domesticated animals, local farmers would loan them as models.

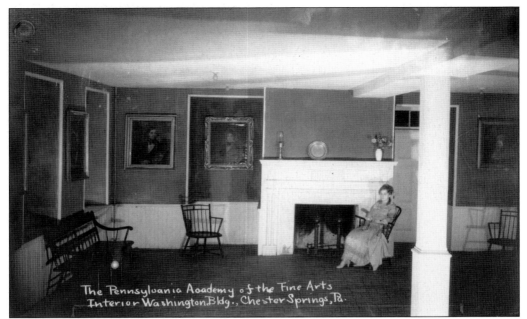

The Pennsylvania Academy of the Fine Arts
Interior Washington Bldg., Chester Springs, Pa.

This interior photograph of the Washington Building shows the brick room, so named because of the brick floor. Most of the building was the male dormitory and dining hall. But the brick room was reserved more for display than actual use. It held trustee-donated early American furnishings and an exhibit that commemorated George Washington's affiliation with the village.

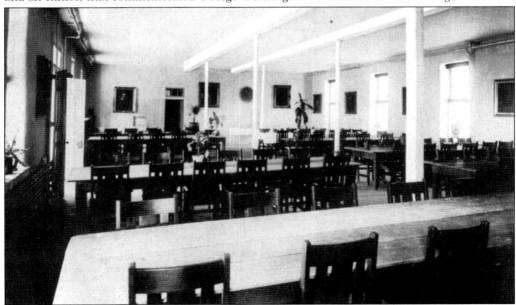

This image shows the interior of the Washington Building's first floor, which served as a dining hall for the country school. Students not only learned and played at the school, but many of them also worked in order to receive reduced tuition. According to Roswell Weidner during a 1998 interview, "I mowed the lawn, washed dishes, [and] there was a swimming pool here and I kept it clean—that was my job."

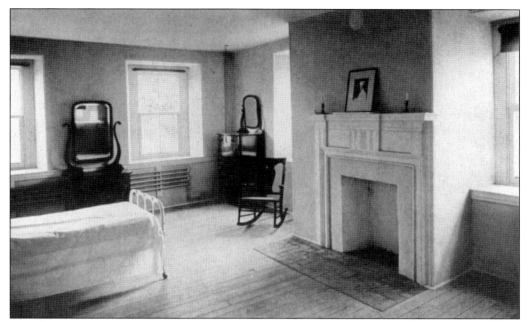

This bedroom on the second floor at the east end of the Washington Building may have been one of the private rooms available to students at the school. According to the school's 1924 catalog, board, lodging, and tuition for students was $15 per week for those living in the dorms and $20 per week for those in private rooms.

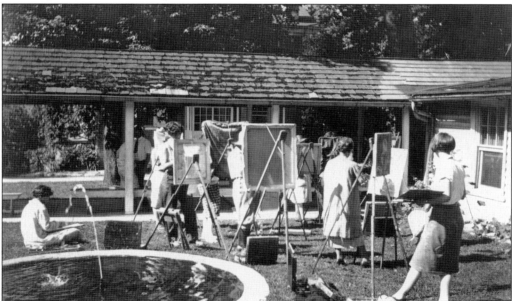

The fountain next to the Washington Building was a fixture since the early days of the art school. In a story recalled by a former student, on one hot day "a handsome girl from Oklahoma" filled her hat with water and emptied it over her instructor's head. The instructor then "seized the flapper" and tried to dunk her into the fountain. Needless to say, the former student continued, "we didn't learn much about the technique of painting on that afternoon."

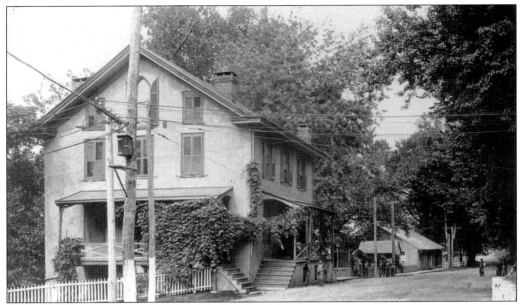

Some of the faculty that lived in the village resided in the Main House, known today as the Rosato House. The colonial fireplace on the ground floor was a social hub. There students and faculty gathered for tea time every day from 4:00 p.m. to 6:00 p.m. Student Ida Geyler Tollenger recalled Halloween in 1930. After gathering apples in the orchards, "Mr. [Roy] Miller invited us to continue in the tearoom where we had ice cream, tea and cakes and sang songs for a long time. By the time we got all the makeup and masks off it was 2 a.m. Everyone said it was the best party they ever went to."

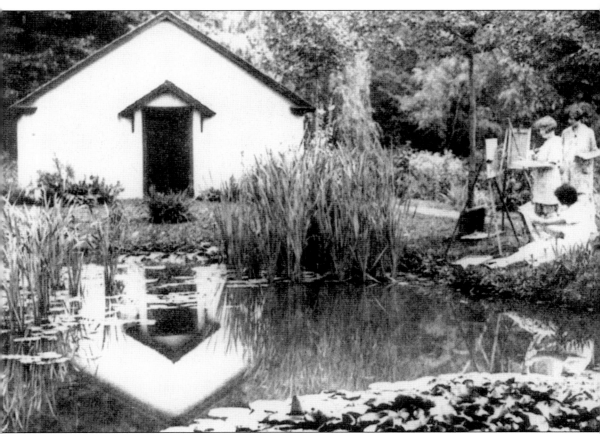

In the early 1920s, John Frederick Lewis hired English gardener Edward Steadman to create a bog garden in the meadows between the Crystal Diamond and Jenny Lind Springhouses. When Steadman put in the bog garden seen here, he had several workers from Phoenixville to help him with the project. Such projects gave the students a wealth of subject matter to paint. The bog gardens created a maze with irises planted around the bridges and ponds. Around the Crystal Diamond Springhouse, yellow and white daffodils sprung from the ground with two japonica shrubs. The rest of the grounds, too, received care and attention to meet the artists' palette. In 1922, the groundskeeper reported that "the energy is directed toward securing sufficient color in its surroundings by planting shrubs and flowers to meet the aesthetic requirements of such an institution." (Courtesy of the Pennsylvania Academy of the Fine Arts.)

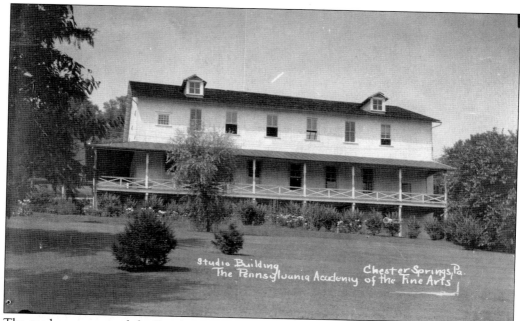

The academy converted the Revolutionary War hospital, which was rebuilt after a fire during the orphan school era, into a studio by adding a large skylight to the rear north side of the building. The school used the studio mostly during inclement weather for painting. It also included a stage that the students used for plays and other performances, as well as a full, indoor volleyball court.

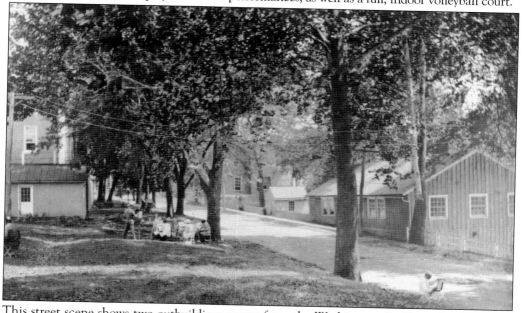

This street scene shows two outbuildings across from the Washington Building that no longer exist. The school used the building in the foreground as a gallery for students to display their works and as a frame-making shop. Exhibitions were a regular part of life at the country school and artists such as Edward Redfield, John Folinsbee, N. C. Wyeth, and others displayed their work there.

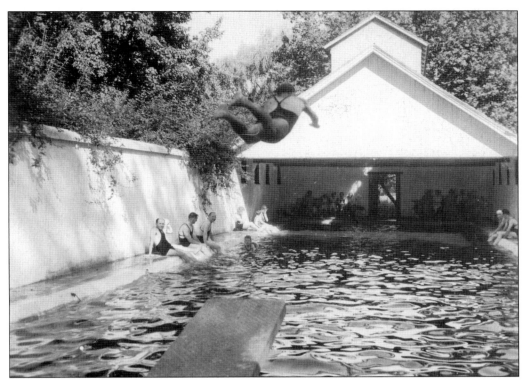

In 1922, the academy added the swimming pool onto the laundry building, originally built during the orphan school era. To create a constant water flow for the pool, the school dammed a branch of the Pickering Creek to form a large pond. A water intake system drew straight from the pond. In 1922, pool house rules stated that the bathing hours were from 6:00 a.m. to 8:00 a.m., 11:30 a.m. to 1:00 p.m., and 4:00 p.m. to 9:30 p.m. The school encouraged the female students to be modest y banning the tight fitting "Annette Kellerman" bathing suits as a sole garment.

In this photograph, a female student serves on the tennis courts constructed in 1922. The women of the Chester Springs Country School enjoyed the burgeoning freedoms of the 1920s. They wore trousers, smoked cigarettes, and led an active lifestyle at the school. As explained by former student Blanch Lomisch Alexander during a 1998 interview, "We lived a free life" and wore shorts, which sometimes offended the local farmers who did not want their children witnessing such behavior.

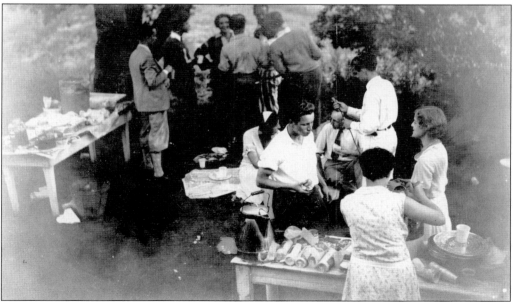

The country school was full of activity year round, with picnics, dances, and a wide array of social activities in addition to the students' studies and work. Former student Beth Clardi recalled that "they would come around and tap on all the doors and say we're going to square dance tonight, and everybody would come down and we would square dance." Roswell Weidner, student and teacher at the school, is in the center of this photograph looking down at the table.

Despite the rigorous school schedule, there was plenty of time for students to relax. Here students lounge in the courtyard between the Washington and Lincoln Buildings and enjoy reading the Sunday newspaper and funnies.

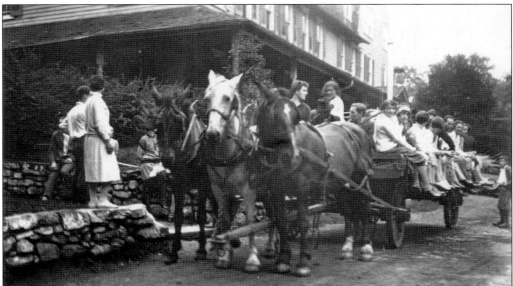

The students at the school interacted frequently with the local residents in the area. Local residents often offered to be models for the students and the school's food came from these same local farms. The students painted area landscapes on surrounding farms and hillsides. In fact, in 1922, the academy issued a rule that "paint must not be wiped on grass, fences or buildings. Paint rags must not be left lying around, but brought home and burned."

When the school was open year round from 1927 to 1933, the campus became a winter wonderland during the cold months. Students tried their hand at skiing and tobogganing behind the Lincoln Building on what was known as spring hill. According to a 1929 article on the school, in winter there was plenty of "skiing, tobogganing, and skating when the weather is favorable." One student recalled skiing down the hill in winter with a jump where the hill met the road. When the weather was cold enough, the pond on the Pickering Creek branch made the perfect ice-skating rink for the students.

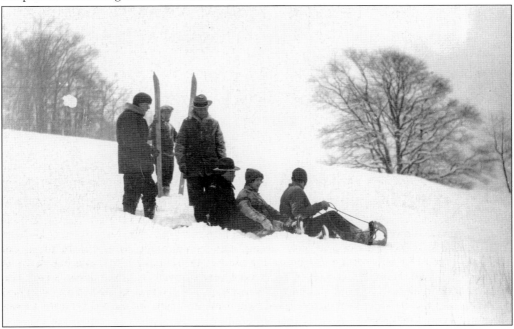

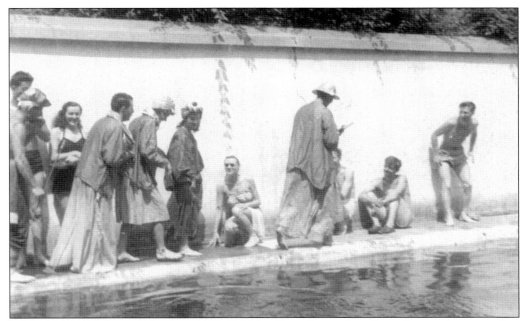

As one of the many social activities of the school, students often dressed up and put on skits around the village for entertainment. On rainy days, they would put on plays and the farmers' children became their attentive audience. Always ready to dress up, at the end of the year students enjoyed a big costume party.

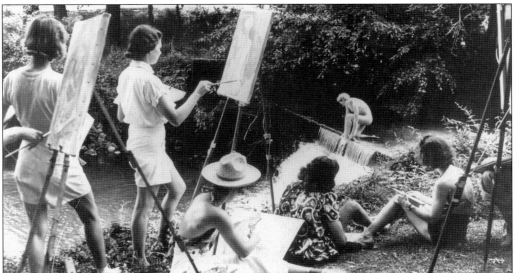

This 1939 image shows students painting a nude figure on the dam. "I am also planning," school manager Joseph T. Frazer penned in 1934, "to emphasize very strongly, the use of the life model outdoors, which I believe will be unique in any summer art school and if I can but prove its desirability, I shall stress this branch of our school very strongly in future advertising." The painting of the nude outdoors was an innovative technique. When nudes posed in the courtyard between the Lincoln and Washington Buildings, bamboo scrims blocked the view so local residents were not offended.

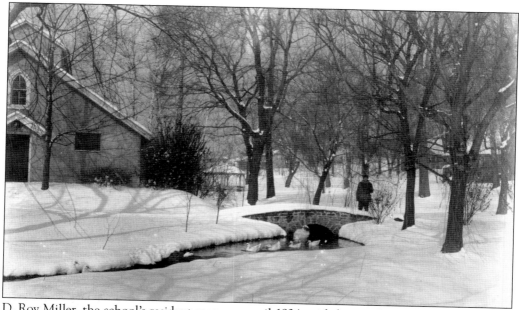

D. Roy Miller, the school's resident manager until 1934, said that a school of winter landscape was filling a real need in American art education. He wrote, "Although the trend of art in America has been steadily in the direction of landscape—and from the large number of snow paintings in the current exhibitions it might almost be said 'winter landscape'—until now there has been no important school, situated in the country."

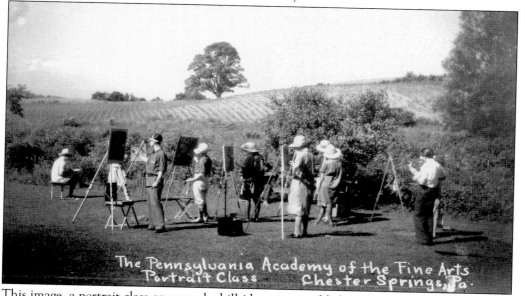

The Pennsylvania Academy of the Fine Arts Portrait Class Chester Springs, Pa.

This image, a portrait class on a nearby hillside, was most likely taken in the early 1920s. The surrounding landscape and farms provided an endless array of painting possibilities for the students and teachers to create and refine their work. As recalled by former student Jack Gerber during a 1998 interview, "We'd be sitting on a hill painting, and we'd see the old car coming down the road, and he'd [Francis Speight] park and he'd come all the way up the hill to give us a little criticism."

Horse sculptor Evaline Sellors was born in 1903 in Fort Worth, Texas. Her early claim to fame was the creation of "tut's pup" (after King Tut), a stuffed dog that was mass-produced and marketed by Averill Manufacturing Company. The dog's royalties paid her way to the Pennsylvania Academy of the Fine Arts, which she attended from 1925 through 1929. In 1932, she was one of the founders of the Texas School of Fine Arts in Fort Worth.

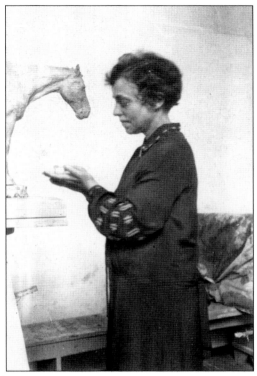

This image shows summer student William Ross Nelson painting a landscape while a student at the school in 1938 and 1939. This photograph titled *August Landscape* was taken in 1938. Decreased attendance led the school to temporarily close when war broke out a few years later.

This photograph shows artist Doris "Dorcas" Kunzie Weidner in 1931 just after she arrived at the country school as a student. She later married instructor Roswell Weidner and went on to become an instructor at the school. Dorcas's work is now in the permanent collections of the Woodmere Museum of Art, Pennsylvania Academy of the Fine Arts, Library of Congress, and Oklahoma Arts Center. (Courtesy of Chester C. Marron.)

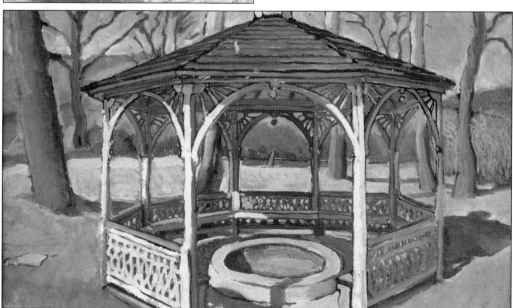

This painting of the Yellow Springs gazebo was done by Virginia McCall. Born 1908 in Philadelphia, McCall attended the academy's country school. She received the highest honors for her humanitarian work making surgical drawings and life masks of plastic surgery cases at the Valley Forge Army Hospital during World War II and the Korean War. The painting was donated by McCall to the HYS Archives.

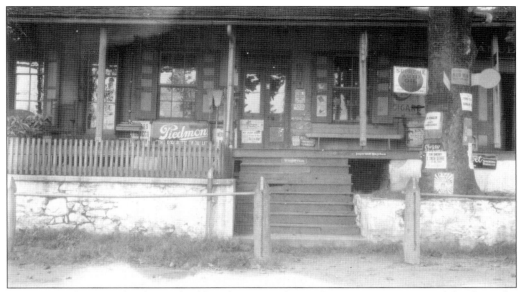

These two photographs show a building known today as Connie's House, named for Cornelia D. "Connie" Fraley, founder of Historic Yellow Springs and the Chester Springs Studio. This old farmhouse in the village, which dates to around 1840, served as Holman's General Store, a post office, and telephone service during the country school era. Joseph Holman ran the store, while his son-in-law John Albert Vail operated the post office and telephone switchboard. Katharine Ann Vail, Holman's granddaughter, recalls living in this building as a child in the early to mid-20th century. She operated the switchboard as a young teenager, and her sister used to pose for the artists at the school. (Below, photograph by Robert F. Brinton; courtesy of the Chester County Historical Society.)

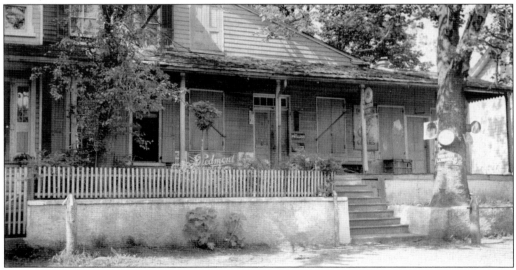

This image shows the building known today as the Vaughn House, named after the Vaughn family who lived there later in the 20th century. During the academy era, the village caretaker, Eli Allen, and his wife called the building home. Allen continued to manage the property when Good News Productions moved into the village in the 1950s. (Courtesy of the Vince Spangler Collection, HYS Archives.)

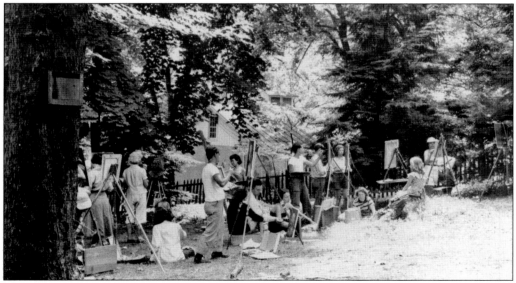

This 1950 photograph shows a young Mary Garden Norris Moffet posing for a portrait class across from the Lincoln Building. Moffet spent her summers living in the Vaughn house with her uncle Eli Allen, the village caretaker. She often modeled for the artists. This photograph was a gift of Michael Iacocca to the HYS Archives.

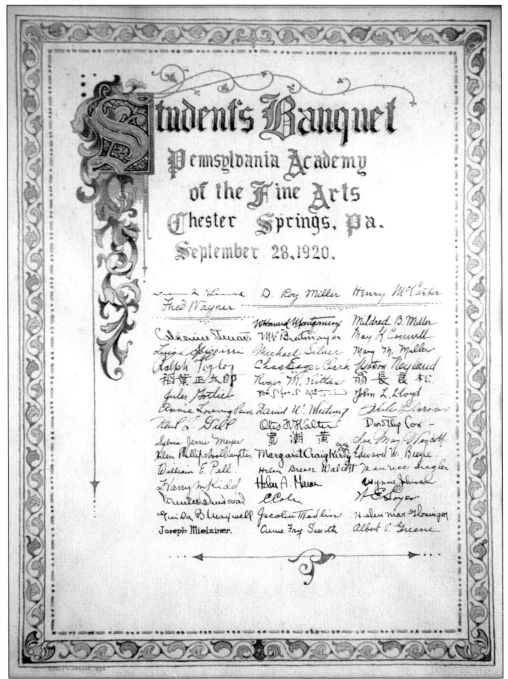

Each fall, the works of the country school artists culminated in a large exhibition at the academy's main campus in center city. This certificate commemorated the banquet held at the end of the 1920 summer season. Some 44 students, staff, and faculty signed the commemorative document, including Roy and Mildred Miller, Joseph Lewis, Fred Wagner, Henry McCarter, and Albert Van Nesse Greene. This certificate was donated to the HYS Archives by Irvin S. "Shorty" Yeaworth.

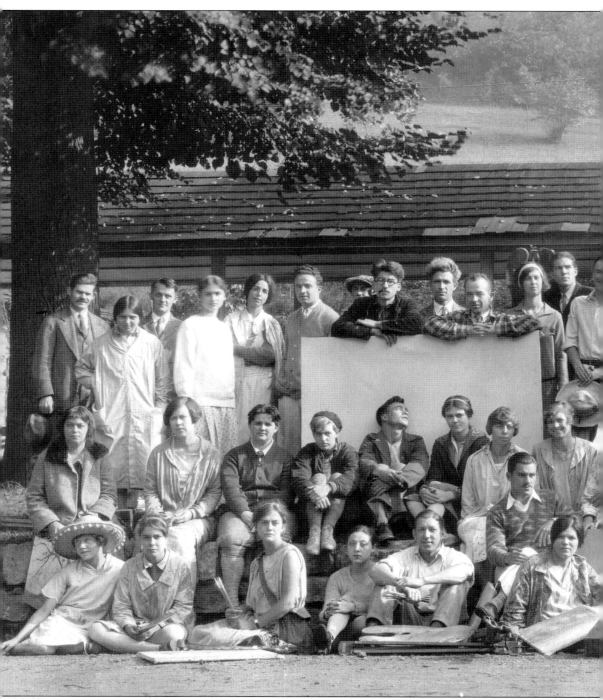

The faculty and students posed for many group portraits with their works, such as this one taken between the Lincoln and Washington Buildings. The distinctive Daniel Garber stands near the center in the third row in a bow tie with palette in hand. Sculptor Albert Laessle stands on the far right in the third row. Despite the active and communal environment that the students

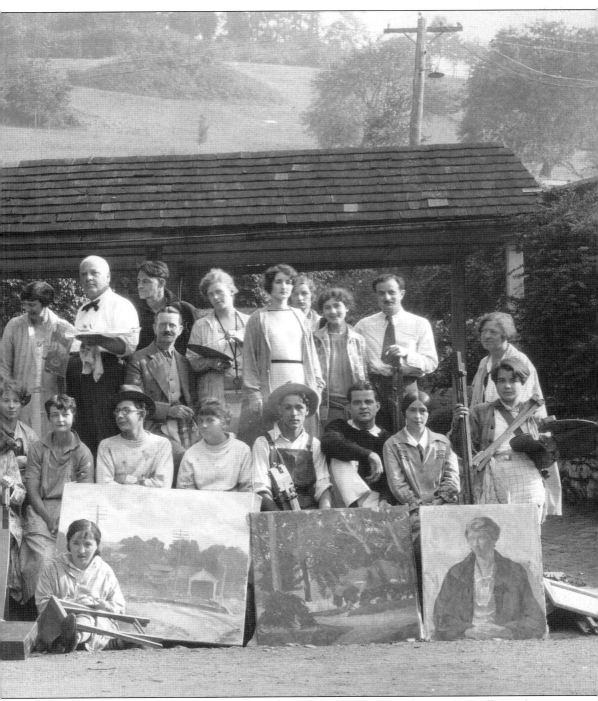

enjoyed, they were fairly isolated from the rest of the world. According to Roswell Weidner during a 1976 interview, the "public seldom came" and they rarely had public exhibitions at the campus. "Once in a while," he continued, "the Pennsylvania Horticultural Society visited to see the grounds." (Courtesy of John Suplee.)

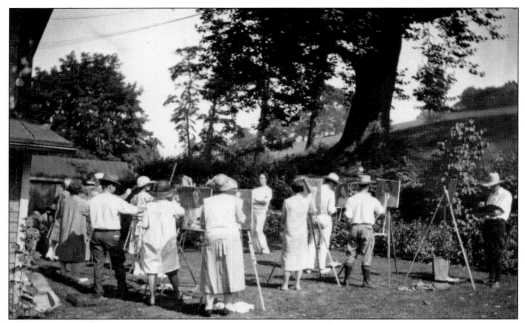

This portrait class was held behind the Washington Building under the large sycamore tree that survives to this day. The tree not only provided shade and landscape painting material, but the common dinner bell also hung from the tree, which rang to alert students and faculty of mealtime.

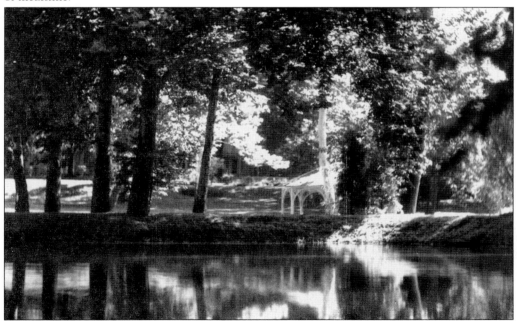

This serene view shows the gazebo behind the large pond created when the school dammed the creek in 1921. The dam was 125 feet wide and created a body of water 400 feet long where the students ice skated in the winter and rowed boats in the summer. The beauty of the pond and dam gave students a prime setting for their landscape painting.

Four

GOOD NEWS
PRODUCTIONS

There is something magical about the cinema.

—Irvin Shortess Yeaworth Jr.

The creative and artistic atmosphere of rural Chester Springs was stirred into a new genre when movie making arrived in 1952. A young film director-producer had purchased the historic village of Yellow Springs and set up studios here. Irvin Shortess "Shorty" Yeaworth Jr. (1926–2004) saw this location as ideal for his Christian and educational films. His outfit, Good News Productions Incorporated, was a non-profit corporation dedicated to the presentation of the Christian message through television, radio, and film.

Yeaworth went on to become the principal producer of religious films of his time by believing that he could preach the gospel better with a camera and microphone than a pulpit. During its 22 years in the village, Good News Productions produced over 400 films as well as television and radio shows that focused on this message. Referring to his establishment as "Hollywood on the Pickering Creek," his subsidiary Valley Forge Films produced several well-known films that include *4D Man*, *Dinosaurus!*, and, of course, *The Blob*.

Good News Productions transformed the entire village into work and living space. Staff and crew lived in the village's houses, old hotels, and dormitories. Two barns served as production studios and the old hospital housed the editing facility. The communal lifestyle ensured everyone's care, as the group shared everything according to need. To supplement income for the group, Good News Productions produced commercial projects. Vince Spangler traveled off-site to photograph products for corporate brochures and advertisements.

In 1973, Yeaworth put the village on the market. He went on to produce shows and head up Communications Strategies working in studios around the world making films and designing sets, theme parks, and world's fairs. He was working in Jordan on a project when he was killed in a car crash in 2004.

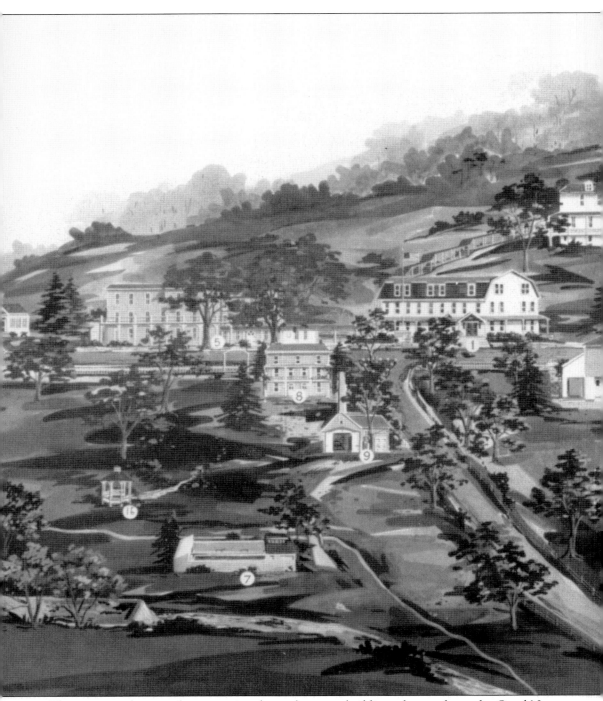

This painting, by an unknown artist, shows the many buildings that made up the Good News Productions facilities. Number one, the Lincoln Building, held offices, laboratories, dormitories, and a screening room. Number two, Studio A, housed a recreation room and sound operations after number three, Studio B, burned down in 1962. Number four, Studio C, had a stage and

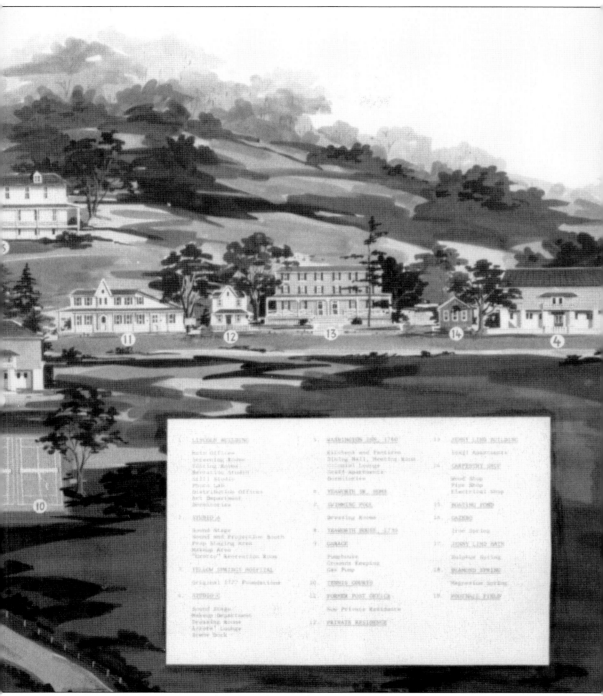

actors's preparation areas. Number five, the Washington Building, served as living and dining quarters. Numbers six and eight were the home of Shorty Yeaworth's parents and his family, respectively. Number nine, the old powerhouse, served as the water pumping house and garage with a gas pump. This painting was donated by Jean Yeaworth to the HYS Archives.

Studio A at Good News Productions was the old barn structure located across from the Lincoln Building. This building, used as stables during the orphan school and a sculpture studio during the academy, included a sound and production stage, sound and projection booth, prop staging area, makeup area, and a recreation room known as the Grotto. (Courtesy of the Vince Spangler Collection, HYS Archives.)

Good News Productions converted the rebuilt Revolutionary War hospital into their editing and music studio, called Studio B. In 1962, sparks from burning brush ignited the studio and burned it to its stone foundation. It was a devastating blow to Good News Productions, as sound equipment, stock shots, music tracks, the film library, lighting, and amplifying equipment were all lost. (Courtesy of the Vince Spangler Collection, HYS Archives.)

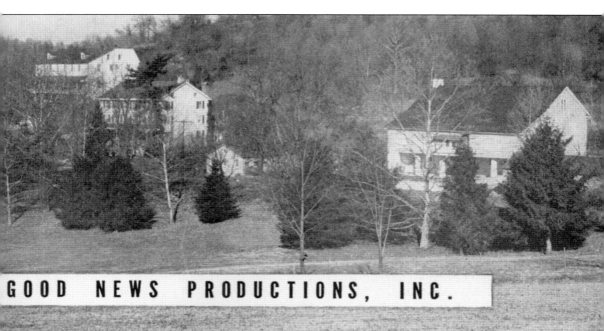

GOOD NEWS PRODUCTIONS, INC.

This 1950s promotional brochure, donated by Lucy Woodland to the HYS Archives, described all of Good News Productions' services in radio, film, and motion pictures. It announced: "You Should know . . . that it takes good people with good ideas and good equipment to make good motion pictures. These are available at the 160 acre film center of Good News Productions, Inc." The building on the right, known as Studio C, provided film production space for many of Good News Productions' movies and television shows. Originally built as a barn, Studio C had served the Pennsylvania Academy of the Fine Arts as a sculpture studio. Good News Productions used the building for a wide array of projects, including *The Blob*. Many of the outdoor scenes in *The Blob* were actually filmed inside this building, which was converted through set design to have the appearance of the outdoors.

Husband and wife team Shirley and Rudy Nelson served as scriptwriters and assistants to the director for Good News Productions from 1951 to 1954. They worked on a variety of films and programs, including *Banderilla, Buttonwood Inn, Singing Towers, Siesta,* and *Burning Answer.* They returned midsummer 1957 to assist with *The Blob.* Like everyone else at Good News Productions, they also pitched in wherever needed. Rudy later became a professor of English at the State University of New York in Albany. (Courtesy of the Vince Spangler Collection, HYS Archives.)

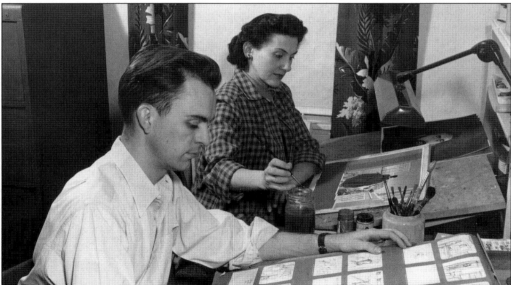

Here Bill Jersey and Ruth Kratz illustrate a storyboard for the production of *Jonah and the Whale.* Storyboards such as these were used to capture a still image of each major scene. Jersey went on from Good News Productions to become a leading documentary filmmaker. He has won numerous awards, been nominated for several Academy Awards, and continues to produce cutting edge documentaries with his company Quest Productions. (Courtesy of the Vince Spangler Collection, HYS Archives.)

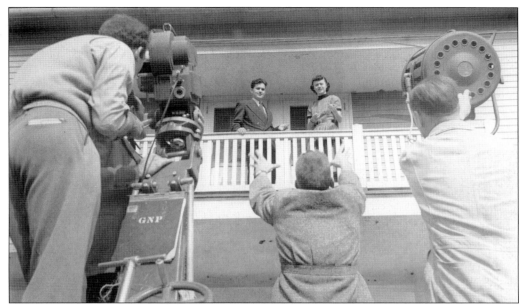

This 1954 photograph of an unidentified movie being shot at Studio C balcony shows Tom Spalding on the camera, Shorty Yeaworth below, and Vince Spangler on the right doing the lighting. These men were the original three when Good News Productions was started. They began in Philadelphia with a still photography studio before expanding their operation to focus on film and later moved to Chester Springs. (Courtesy of the Vince Spangler Collection, HYS Archives.)

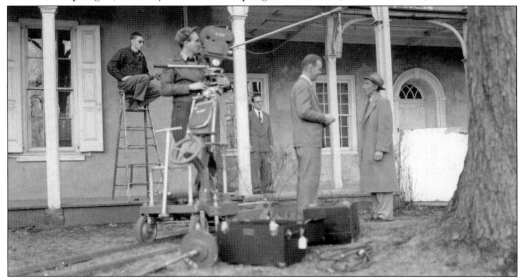

The 1953 film *Buttonwood Inn* used the Washington Building as its title subject, seen here in the background. The film told the story of a hotel manager's conversion. Shorty Yeaworth stands on a ladder directing in the background while Good News Productions actors Rev. Victor Alfsen and George Wright are being filmed. Alfsen also served as Good News Productions's chaplain and production designer. Rev. Milton E. Van Slyke of the nearby West Vincent Baptist Church and local postmaster J. Albert Vail also appeared in the film. Wright worked mostly with the makeup and props. (Courtesy of the Vince Spangler Collection, HYS Archives.)

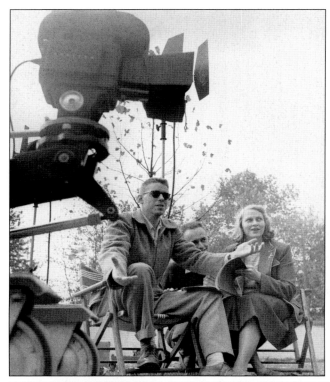

These images show the filming of the movie *Desperate Measures*, made in 1956 as a recruiting film for the Salvation Army. The image at left shows Shorty Yeaworth and wife, Jean, on the set with Shorty directing and writer Rudy Nelson in the background. Below, Shorty kneels as he directs portions of the film behind the Main House. Producer Jack Harris first met Shorty when he visited the village during the filming of *Desperate Measures* and soon thereafter signed a contract to produce *The Blob*. (Courtesy of the Vince Spangler Collection, HYS Archives.)

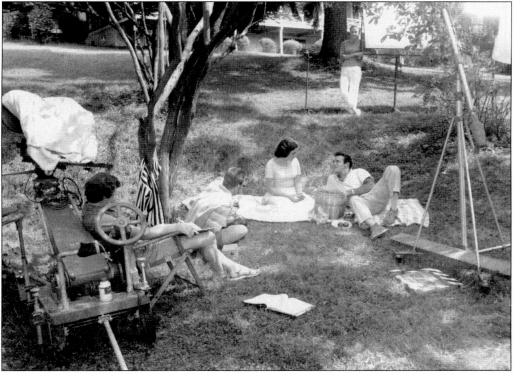

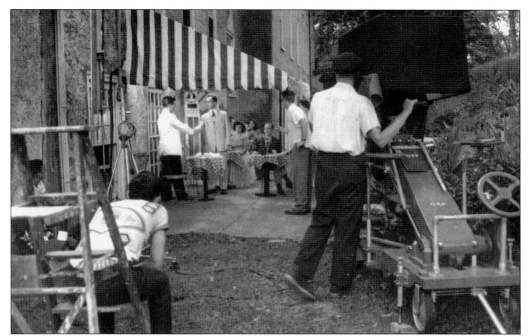

These two images show the filming of *Burning Answer* in the village. In the above scene, Good News Productions recreated a café behind the Washington Building. Below, Shorty sits in a chair directing an outdoor scene under the pillars of Studio C. *Burning Answer* was a 3-D film made primarily for churches. It was a mystery film with a plot that focused on missions in Europe; however, the movie was never as successful as Good News Productions hoped it would be. (Courtesy of the Vince Spangler Collection, HYS Archives.)

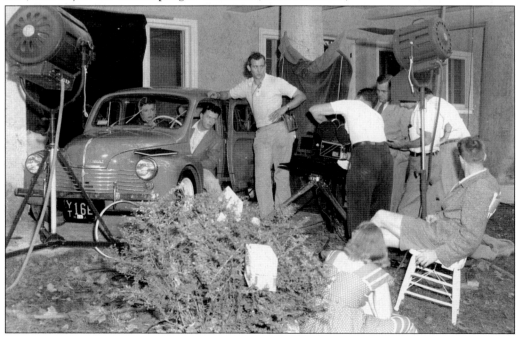

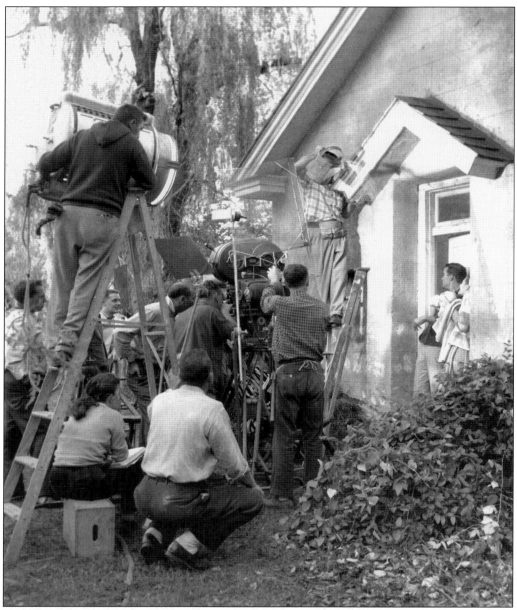

This photograph shows the set of *4D Man*, a 1959 science-fiction film about an experiment gone awry, which left main character Scott Nelson (played by Robert Lansing) able to pass through solid objects. Nelson used his new found powers to fulfill his every wish, acquiring money, fame, and wooing his girlfriend, Linda Davis (played by Lee Meriwether). In this image, Davis and Nelson's brother Tony (played by James Congdon), stand in front of the Jenny Lind Springhouse at Yellow Springs. The watering can provided the fake rain for this particular scene, where the two steal a secret kiss in the springhouse when seeking shelter during a storm. Jack Harris produced the film, using the advance he received from distribution of *The Blob*. When the movie was released on October 7, 1959, it carried the tagline "He walks through solid walls of steel and stone . . . Into the 4th Dimension!" (Courtesy of the Vince Spangler Collection, HYS Archives.)

Child star Patty Duke played the cameo role of Marjorie Sutherland in *4D Man* at the age of 11 or 12. Duke went on to win an Academy Award for best supporting actress just a few years later in 1962 for *The Miracle Worker*. At that age of 16, she was the youngest person to win an Oscar and youngest to have her own television series, *The Patty Duke Show*. (Courtesy of the Vince Spangler Collection, HYS Archives.)

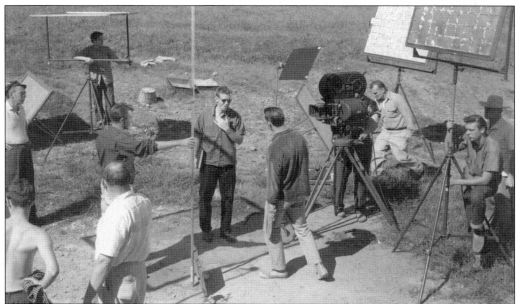

In this photograph, Shorty Yeaworth (center) directs Steve McQueen during a local scene of *The Blob*. *The Blob* began under the title *Molten Meteor*, a film inspired by a gooey silicon substance brought to Yeaworth's attention by Irvine H. Miller, head of visual aids for the Boy Scouts of America. Produced by Jack Harris and directed by Yeaworth, all of *The Blob's* scenes took place in the village and nearby areas. Local artist Jasper Brinton did the lighting. (Courtesy of the Vince Spangler Collection, HYS Archives.)

The 1966 movie *Way Out* was a full-length production that dealt with drug addiction and told the story of drug users in New York City. The stars of *Way Out* were real and recovering drug addicts. They got their start by traveling to churches and performing plays about their lives to promote social change. Shorty Yeaworth brought the addicts-turned-actors to Yellow Springs where they recreated their plays. He filmed them, added music, and made the movie *Way Out*. The film was a huge success, with regular showings such as this one geared towards changing the lives of those involved in or susceptible to drug use in the 1960s. The movie was later recognized at the Cork Film Festival in Ireland and was sponsored by famed singer and born-again Christian Pat Boone. The film is still shown in prisons today. (Courtesy of the Vince Spangler Collection, HYS Archives.)

This television show, titled *Secret Island*, starred Larry McGill. Like others, the show was produced in Studio C. *Secret Island* was a program that offered moral lessons for preschoolers. It had a one-year run and was the first regularly scheduled videotaped series in the United States. (Courtesy of the Vince Spangler Collection, HYS Archives.)

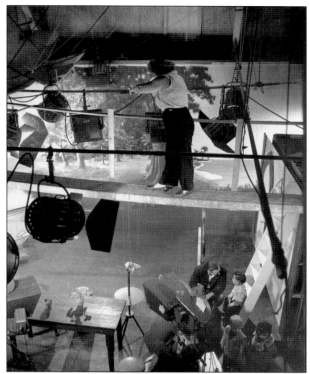

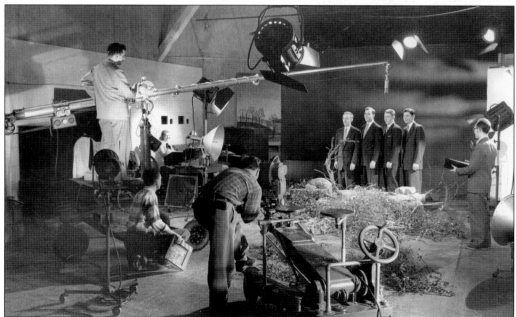

This photograph, taken in Studio B (old Revolutionary War Hospital), shows Vince Spangler filming the Gospel Quartet consisting of, from left to right, Rudy Nelson, Tom Spalding, Shorty Yeaworth, and Dan Barstow. Bill Jersey was the boom man and Jean Yeaworth played the piano. (Courtesy of the Vince Spangler Collection, HYS Archives.)

The prop shop, also known as the carpenter's shop, was located in the old chicken coop building that was next to Studio C. This is where all of the sets were built and machines and tools stored. The building burned to the ground in the 1980s and was rebuilt by the Yellow Springs Institute, which owned the property at the time. (Courtesy of the Vince Spangler Collection, HYS Archives.)

Here film technician Godfrey Buss (foreground) and film editor John Ayling (background) work sometime between 1952 and 1955. Buss later worked as the sound director for *The Blob*. They are working on the sound for a film, which, at that time, was always done separately from the film. (Courtesy of the Vince Spangler Collection, HYS Archives.)

Many staff members were involved in the behind-the-scenes process of bringing a work to completion. The above 1954 image shows engineer John Kratz (front) and summer help Dick Kesser (back) synchronizing the sound and film for a production. In the photograph below, Lois Harding (back) and film editor and public relations executive John Ayling (front) work on editing film. Ayling also worked with Shorty Yeaworth, Jean Yeaworth, and others as the cinematographer for the film *The Flaming Teen-Age*, which was produced in 1956 to show the dangers of teen alcohol consumption. (Courtesy of the Vince Spangler Collection, HYS Archives.)

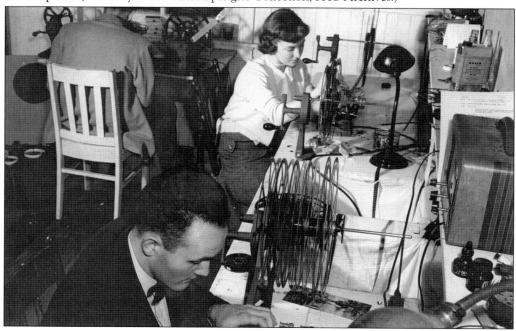

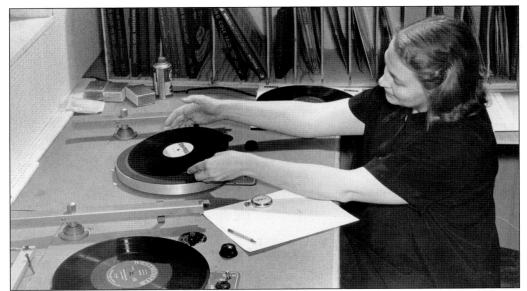

Shorty Yeaworth's wife, Jean, seen here working on sound effects for a production, was involved in all aspects of Good News Productions. Today she recalls many all-nighters spent working in the editing room, trying to meet deadlines. On one such late night, she recalls synchronizing and editing six tracks (one film and five sound) in Studio B. When she accidentally placed the cuts on the wrong side, about 35 feet of film spewed out all over the building before her husband came to her assistance. (Courtesy of the Vince Spangler Collection, HYS Archives.)

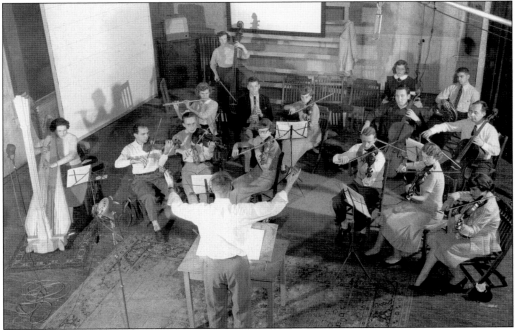

This 1954 photograph shows Shorty directing the music for the film *Burning Answer*. This scene was most likely in Studio B, the old Revolutionary War hospital site that burned to the ground in 1962. (Courtesy of the Vince Spangler Collection, HYS Archives.)

Vince Spangler had a darkroom in the Lincoln building. Spangler took photographs not only for Good News Productions, but also to photographically document the history of Yellow Springs as part of Historic Yellow Springs during the 1970s. Shown here, his darkroom in the Lincoln Building now serves as storage for Historic Yellow Springs. (Courtesy of the Vince Spangler Collection, HYS Archives.)

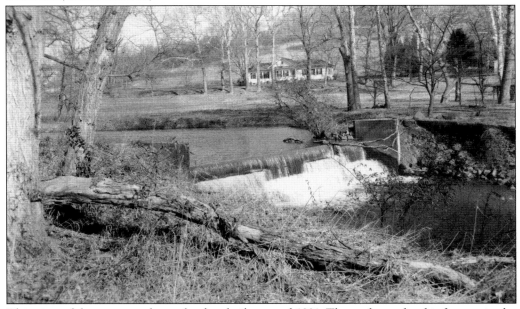

This view of the property shows the dam built around 1921. The orphan school infirmary in the background was converted to a residence during the Good News Productions era. According to local tradition, Steve McQueen honeymooned in the infirmary with wife, Neile Adams, in 1956 during the shooting of *The Blob*. It later served as the residence of Dr. and Mrs. Irvin Yeaworth, the parents of Shorty. (Courtesy of the Vince Spangler Collection, HYS Archives.)

As these 1954 photographs demonstrate, Good News Productions was a tight-knit community. The above image, which bears the title *Weekly Meeting of Good News Family*, shows Shorty Yeaworth giving a talk in front of the fireplace in the Washington Building's Brick Room. In the publicity shot below, Laurie Jersey (left) and Virginia Ayling carry a ladder in front of the Washington Building. At Good News Productions, everyone helped with all operations. Jersey and Ayling were wives of some of the men who worked there and painted sets or contributed to the operations in other ways. For the first few years that Good News Productions operated in the village, people sometimes worked without pay. (Courtesy of the Vince Spangler Collection, HYS Archives.)

Meals at Good News Productions were taken communally on the ground floor of the Washington Building and included everyone involved in the operations. On the left sits Eli Allen, caretaker of the village who also worked for the Pennsylvania Academy of the Fine Arts. On the right, from front to back, sits office manager Jane Spangler, writer and actor Ethyl Barrett, and production manager Ralph Nichols. (Courtesy of the Vince Spangler Collection, HYS Archives.)

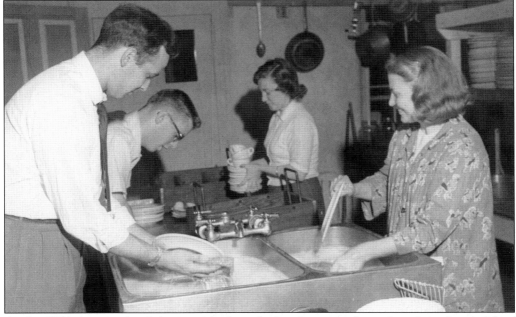

As this 1954 photograph exhibits, everybody pitched in during mealtime. In order to keep track of duties, everyone signed up on a chart to help out in shifts. Here several of the Good News Productions staff are all washing dishes, including, from left to right, Tom Spalding, Shorty Yeaworth, Lois Harding, and Jean Yeaworth. (Courtesy of the Vince Spangler Collection, HYS Archives.)

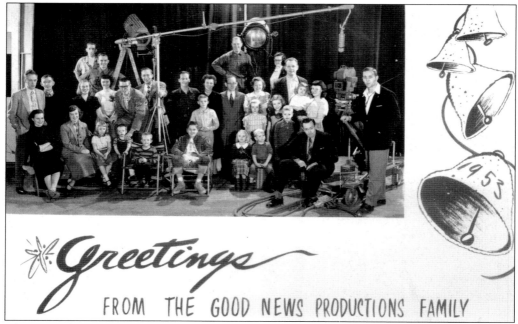

This 1953 Christmas card from Good News Productions shows all of the Good News Productions family on one of their stages. The family included the wide array of professional staff and their families that worked and lived in the village. This included production managers, scriptwriters, sound recorders, photographers, animators, cameramen, lighting technicians, actors, assistant directors, prop people, makeup people, and press representatives. They all worked together, sometimes around the clock, to create the moving pictures.

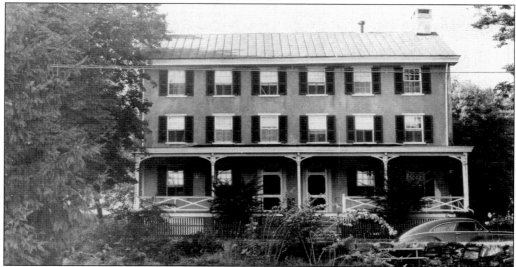

The Jenny Lind House, built originally as a boarding house by Margaret Holman, served as apartments for the Good News Productions crew. In the mid-19th century, Jenny Lind supposedly stayed in the building during her visit. The building later became the farm that the Pennsylvania Academy of the Fine Arts purchased in 1928. The academy used the building as faculty and student living quarters. (Courtesy of the Vince Spangler Collection, HYS Archives.)

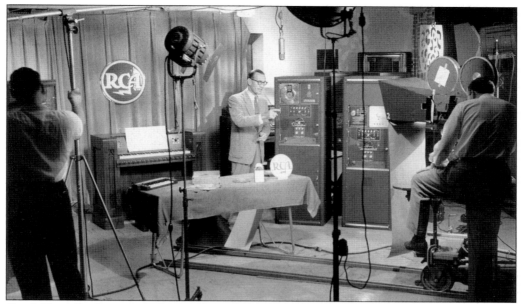

Good News Productions took outside contracts to make extra money, which subsidized their educational film and production work. Above, Good News Productions' photographer and cameraman Vince Spangler is on right behind the camera during a commercial shoot for RCA. Below, Spangler films a woman using equipment from the Burroughs Corporation, a major computer company located nearby. Spangler also did work for the Chemical Paint Company, Wiedersham Associates, and Weedone. Spangler's career with these corporations predated his work with Good News Productions and continued throughout his years in Yellow Springs after Good News Productions disbanded. (Courtesy of the Vince Spangler Collection, HYS Archives.)

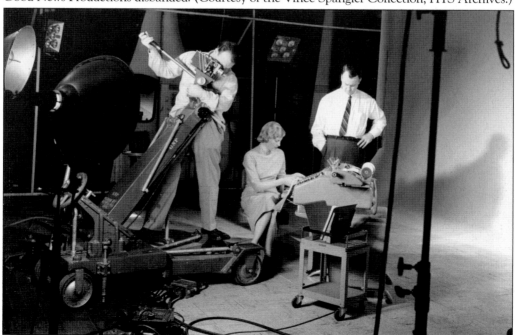

Throughout the Good News Productions era, the village of Yellow Springs was a stop for travelers as part of the American Youth Hostel program. The Washington Building held accommodations for 12 boys and 12 girls, some of which traveled by the nearby Horseshoe Trail. The program allowed Good News Productions to make extra income and reach more youth with their gospel message. The metal symbol shown here clearly marked the Washington Building as a hostel.

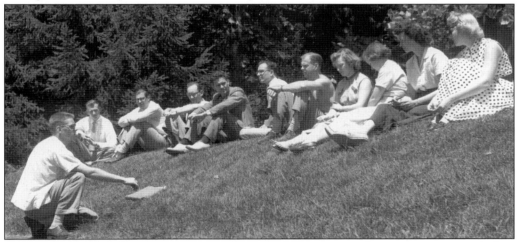

Good News Productions engaged in a wide array of Christian production activities, including training future producers, editors, and directors. The summer seminars, shown here in 1953, brought leaders in the field to teach attendees. Cost to attend summer seminars was $100 for three weeks, which included meals. (Courtesy of the Vince Spangler Collection, HYS Archives.)

Five

THE MODERN ERA

This place is too important!

—Cornelia D. Fraley

In 1965, Cornelia D. Fraley, a young wife, mother, and neighbor, approached Shorty Yeaworth about using the Yellow Springs property for programs for the many new families who were moving into the area. Along with Yeaworth, she organized programs in art, music, science, and history in the historic buildings. That year, the group formally banded together as the Yellow Springs Association and several years later in 1971 had the property listed on the National Register of Historic Places.

When the village came up for sale in 1973, Fraley and the association sprung into action. In 1974, with the financial support of another organization, the Yellow Springs Foundation, they purchased the entire village to preserve it for future generations. The two organizations merged in 1976 to become Historic Yellow Springs, Incorporated.

The mission of Historic Yellow Springs was multifaceted. It included ensuring the preservation of the buildings and the surrounding land, restoring the buildings, creating a center for the encouragement of activities and programs related to history and the arts, the conservation of cultural heritage, and the nurture of the physical environment. Fraley was the leader of this grassroots group that continued on to fulfill this mission.

Meanwhile, several other cultural organizations moved into the village with the same spirit of community betterment. The People's Light and Theatre Company was welcomed in 1976 when they established a theater in the large barn studio. The Yellow Springs Institute for Contemporary Studies and the Arts arrived in 1979, representing the performing arts in new and innovative ways. Local residents founded the Chester Springs Library in 1976 to advance literary pursuits. The Chester Springs Studio, founded in 1978 as an offshoot of Historic Yellow Springs, perpetuated the village's artistic tradition with art classes and cutting-edge exhibitions.

In the village of Yellow Springs, history, art, and culture continue to prosper and grow in a unique natural environment. This place is a continuing stream of events, lives, and incidents of both local and national significance—much of it deeply stirring, some of it amusing, some of it tragic, and all of it priceless.

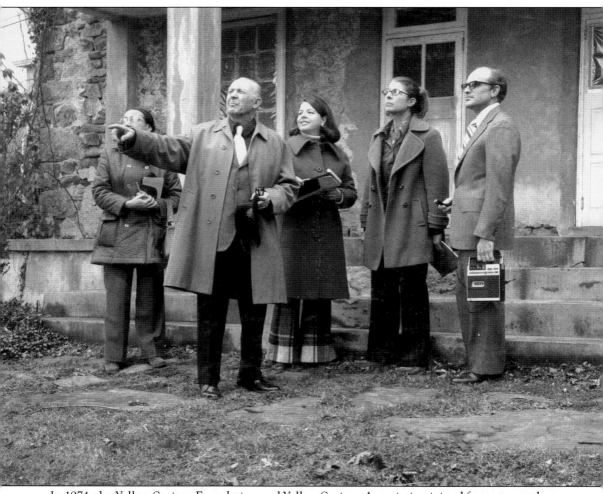

In 1974, the Yellow Springs Foundation and Yellow Springs Association joined forces to purchase the village of Yellow Springs to preserve it for future generations. Here a notable group views the property behind the Main House, later known as the Rosato House. This group included, from left to right, Catherine Smiley, Joseph Frazer, Grace Mohler, Cornelia D. Fraley, and Dick Mohler. Smiley and Grace Mohler worked with others to research and preserve the property's buildings and history. Frazer was the former manager of the Pennsylvania Academy of the Fine Arts Country School. Fraley spearheaded the effort to preserve the village and is considered the founder of the Yellow Springs Association and Historic Yellow Springs. Dick Mohler later served as board president of Historic Yellow Springs. (Courtesy of the Vince Spangler Collection, HYS Archives.)

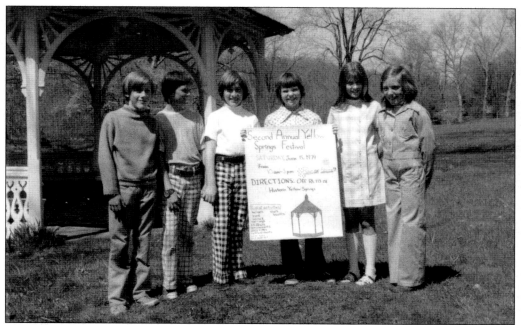

In the early years of the Yellow Springs Association's existence, public programs and social activities were a regular part of life in the village of Yellow Springs. In these images, the Yellow Springs Festival brought the community together for a day of fun and fund-raising to celebrate and preserve the village. Above, local kids stand in front of the gazebo with a sign that reads "Second Annual Yellow Springs Festival, Saturday June 15, 1974," with a list of activities that included everything from balloons and bands to children's amusements and craft booths. Seen below, the streets were blocked off and lined with tables of food for visitors. (Courtesy of the Vince Spangler Collection, HYS Archives.)

Historic Yellow Springs is perhaps most famous for its juried art show, first held in 1973. This image was taken in the large Studio C barn, which hosted the show for many years. Since its beginnings, the show has not only served as a vital fund-raiser but also as a cultural venue for emerging and established artists to bring their work to the public. (Courtesy of the Vince Spangler Collection, HYS Archives.)

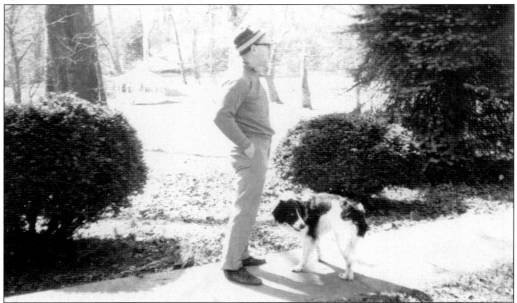

After the end of Good News Productions' time in the village, Vincent Spangler, seen here with his dog Muffin, continued to live in Yellow Springs. Spangler spent nearly a decade as the Yellow Springs Foundation and Historic Yellow Springs caretaker and photographer. Spangler produced or collected photographs from the 1950s until he retired in 1981. Many of those photographs are included in this book. (Courtesy of the Vince Spangler Collection, HYS Archives.)

From 1976 to 1979, the non-profit theatrical group, People's Light and Theatre Company, established their headquarters in the old Studio C barn. The organization was founded in 1974 by Danny Fruchter, Meg Fruchter, Ken Marini, and Dick Keeler. These theater artists aimed to draw on diverse theatrical talents and work within the milieu of the local community. Above is one of the promotional images from those early years. In the below image, Alda Cortese and John Loven pose in a performance of *Twelfth Night* in 1978. People's Light and Theatre Company continues today at their facility in nearby Malvern. Cortese remains as one of their many notable actors. (Courtesy of the People's Light and Theatre Company.)

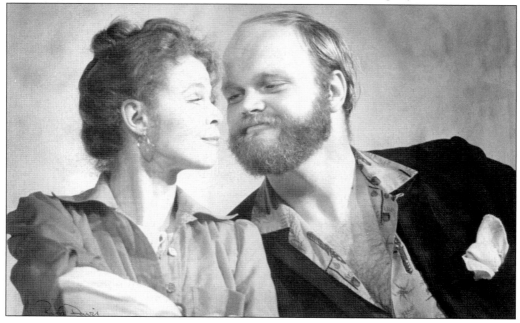

Founded in 1975, visionary John Clauser (left) led the Yellow Springs Institute for Contemporary Studies and the Arts as an experimental arts group. Since 1979, the institute made their home in Yellow Springs village in the old Studio C building, which came to be known as the Cultural Center. Clauser added the Black Box Theater to the space and later built on a conference center. As seen below, Clauser added an earthworks for outside performances. Each year, Clauser chose a handful of artists from around the world. They spent anywhere from 12 days to three weeks together, collaboratively pushing the limits of their craft. Many types of artists, from dancers to musicians and poets, worked together in a tight communal environment before presenting their work in a public performance. In 1997, the institute sold the Cultural Center complex back to Historic Yellow Springs, who, in turn, sold it to West Pikeland Township in 2005. (Courtesy of the Yellow Springs Institute.)

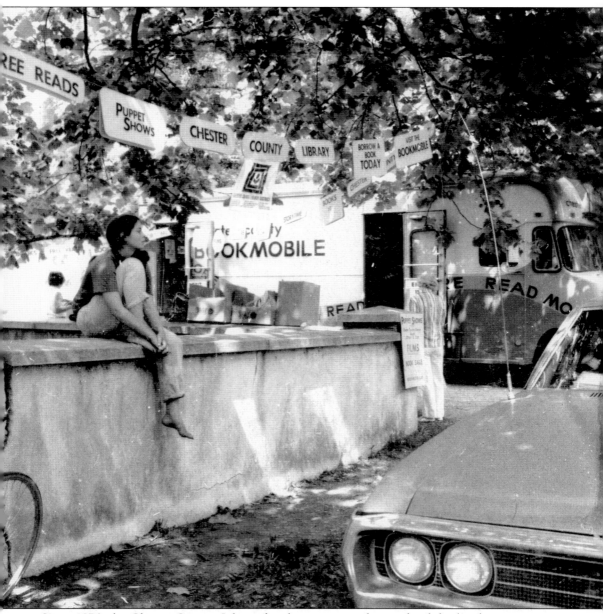

Since 1976, the Chester Springs Library has been serving the needs of the local community. Before the library's founding, the bookmobile stopped by twice a week to offer residents a wide array of books to choose from. Local resident Roberta Rometsch and Historic Yellow Springs founder, Cornelia D. Fraley, first proposed the idea of a permanent library. As interest grew, a group of local residents, including Jack and Rachel Brogan, Anita Focht, Jim McClung, and Barbara Shilling, banded together to found the library in 1976. Initially the library was planned for the old Studio C barn, but eventually found a permanent home in the ground floor of the Lincoln Building. Their initial collection of books, as recalled by 30-year librarian Jan Hall, all came from the local community. The library formally opened to the public in 1978. (Courtesy of the Vince Spangler Collection, HYS Archives.)

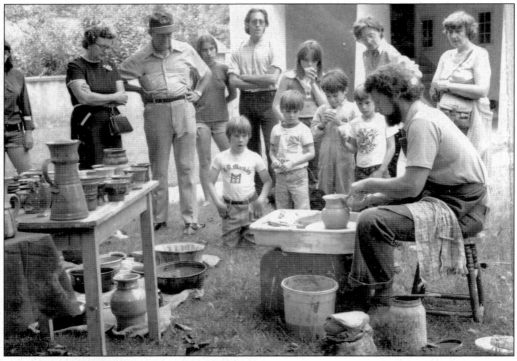

For two years, after the Yellow Springs Foundation and Yellow Springs Association purchased the village in 1974, the two organizations operated separately. In 1976, they merged to create Historic Yellow Springs, Incorporated. In 1978, Cornelia D. Fraley and Lindsay Brinton founded the Chester Springs Studio as an offshoot of Historic Yellow Springs. From then on, while Historic Yellow Springs preserved and carried on the history of the village, the studio promoted the artistic tradition through art teaching. The above photograph shows a pottery demonstration at what would later become the Chester Springs Studio building. The studio's unique wood firing kiln (left) was installed in 1989. (Above, courtesy of the Vince Spangler Collection, HYS Archives; left, photograph by Eileen Ryan.)